Arts & Crafts Shows:
The Top 10 Mistakes Artist Vendors Make...
And How to Avoid Them!

∽∾

Michael Delaware

If, And or But Publishing Company

Copyright © 2013 Michael Delaware

All rights reserved.

This book, or parts thereof, may not be reproduced in any form without permission from the publisher; exceptions are made for brief excerpts used in published reviews.

Published by
'If, And or But' Publishing Company
P.O. Box 2559
Battle Creek, Michigan 49016 USA
www.ifandorbutpublishing.com

ISBN-13: 978-0615911311 (If, And or But Publishing)
ISBN-10: 0615911315

This book contains clipart illustrations which were acquired by means of royalty free usage rights in 2013 and are copyright to: GraphicsFactory.com on the Dedication page, and pages 1, 9, 10, 12-14, 16, 18-24, 27-34, 55, 56, 59-65, 67, 68, 71, 75-79, 82, 85-88, 90, 93-95, 97, 99, 101-107, 109, 111, 113, 116, 119, 121-124, 126, 129, 130, 133, 136, 139 & 147. All other photos and illustrations are the copyright of *If, And or But Publishing*.

While attempts have been made to verify all information provided in this publication; neither the author nor the publisher assumes any responsibility for errors, omissions, or contrary interpretations of the subject matter herein. The views expressed are those of the author alone, and should not be taken as expert instruction or commands.

Dedicated to all the boys and girls of Summer; Arts and Crafts Vendors who make a living as professional artists.

Table of Contents

Introduction..1

Mistake #1: No Preparation/Organization....................7
Mistake #2: Booth Basics Missing...................................25
Mistake #3: Inactive Instead of Proactive Selling......57
Mistake #4: Too Little. Too Much......................................65
Mistake #5: Failing to Draw..73
Mistake #6: Business Killing Practices..........................83
Mistake #7: Choosing the Wrong Show.........................91
Mistake #8: Poor or No Customer Service...................99
Mistake #9: Pricing & Money Errors.............................107
Mistake #10: No Identity Capturing/Follow Up......117

Summary of Key Points..137
Arts & Crafts Show Links..145
About the Author..147

~Introduction~

Whenever one writes a book such as this, it is always a good idea to share one's own background which inspired the writing of it. This journey for me began over 25 years ago as of this writing.

During the 1980's and 1990's I owned and operated a stained and beveled glass door and window design and manufacturing company in the Atlanta metro area. I lived art creation on a daily basis for fifteen years during those times.

In 1991, my business moved our showroom location in Alpharetta, Georgia from a small obscure road frontage to a highly visible location in a neighboring community of Roswell. It was around that time that I joined the local merchants association, and became an active community volunteer for the next decade within

2 ~ Arts & Crafts Shows

this association, even serving as the President of that association for a few years from 1996 through early 1999.

One of the major events that the merchants association held annually was the 'Heart of Roswell Arts & Crafts Festival' which was held every May or sometimes in early June. This festival was held right in front of our storefronts, and covered the entire shopping district we were in spanning five blocks. I served both as a chair and general volunteer in some capacity on this committee from 1991 through 1998, mostly dealing directly with artist vendors.

Over the years I owned my business, my store also did many arts and crafts shows as a vendor participant off and on for over a decade in the 1990's in Georgia, Tennessee and Florida. From 2000 through 2009, after I had sold my business and moved to Michigan, I worked for a book publisher selling self help books, and we also partook in many arts and crafts shows and other festivals whenever they permitted non-artists to take a booth. We sold self help books and materials throughout the State of Michigan, Ohio and Indiana. In 2011 through 2012 my sister who owns a custom made map business where she also sold her paintings and other artwork asked me to help her with arts and crafts shows in the

North Carolina Mountains, and so I again worked as a vendor in shows there as well.

I have taken part in Arts and Crafts shows in various capacities as an artist vendor, a non-artist vendor and a festival coordinator for over 20 years in Georgia, North Carolina, Tennessee, Florida, Michigan, Indiana and Ohio. I even once did a three day weekend selling books on the streets and in the subways of New York City as part of a training program, and I can tell you there is no better place in the world to experiment with huge volumes of people than in the Big Apple. One can literally see thousands of people from every cultural background imaginable in a single day, and it never slows down.

I have also been an avid festival attendee as a customer, and have been to arts and crafts shows in festivals all over the country. Some of those states that I have attended shows were Michigan, Ohio, Indiana, Arizona, Georgia, Florida, Virginia, Maryland, Tennessee, Kentucky, Alabama, Rhode Island, Massachusetts, and California. I love going to arts and crafts shows, and I it always bothers me to see an artist vendor who is hurting their own sales and does not realize it. So I thought it was high time that I wrote a

book about what I have learned, and observed to share with others on this subject.

Over the years I have learned many things about the customer, and how vendors interact with them. I have made each and every mistake in this book at one time or another or seen others make them and cringed. I have learned through hours of experimentation and adjustment to my own booths on what works, and observed and interacted with hundreds of other successful artist vendors over the years and learned and observed their successful actions. This book is intended to compile that information, and make it available to you as an artist vendor or prospective artist vendor so that you can either improve on what you are doing, or launch a successful career avoiding huge costly mistakes.

Not every artist who attends an arts and crafts show is a great vendor. Not every vendor at an arts and crafts show is a great artist. This book will help you understand the art of being a great vendor while showcasing your level of skill as an artist. It is a book about how to avoid the ten biggest mistakes that you can make as an arts and crafts show vendor, and then wind up with a terrible show, and a lot of lost time and a feeling that you are a failure. The truth is, no one really

is a failure as an artist, as long as you have customers who want to buy your work. One can, however, be a failure as a vendor economically if one repeatedly makes costly mistakes.

This book will cover ten basic areas where artist vendors make major mistakes, and either kill or reduce their sales considerably. At the same time, I discuss ways to avoid these costly mistakes. Some are an easy fix, and you may have a few '*eureka*' moments where you say *That is what I have not seen about my booth!'* and a few others where you say *Really? Okay, I guess I will try it...*' and discover later that you have found a gold mine.

No one ever wants to pay for a booth at an '*arts and crafts show*' and walk away with no sales, or not enough sales to even cover your booth fee. This is a business, and one either learns to survive in it or they fail, and that is a fact of any business. This book is intended to help you make your efforts more of a success than failure.

There are certain things that you cannot control obviously, and those two primarily things are a poorly advertised festival by the coordinators, and inclement bad weather that drives customers away. These two variables are in the hands of the festival organizers and

god, and there is little you can directly do about them except move on to the next festival.

Beyond those two variables, the success of the show is entirely in your hands. This book is about maximizing the potential of any well attended arts and crafts show and what actions you can take to make your show a huge success, and avoid common costly mistakes.

There are artist vendors that only do one show a year, and there are many others that travel around all spring, summer and fall doing multiple shows. Some even do shows indoors through the winter months, and make it a year round business. Every type of artist vendor will benefit from the information contained here.

At the end of each chapter in this book, I have listed out the key points for that specific chapter. These key points are also included on one easy reference page at the end of the book as well. Further, I have included in this book a list of useful online references complete with website links for arts and crafts show vendors, including resources to find shows in all 50 U.S. states as well as the individual provinces of Canada.

To your success!

Mistake #1

No Preparation/Organization

When venturing into the activity of having a booth at an art and craft fair, the number one mistake a vendor can make is to not be prepared or organized. This lack of organization can make the difference between having a good show or a lousy one. So in this first chapter we are going to talk about in depth the best ways to approach being organized and prepared for a show.

There are so many different types of arts and crafts, and to cover all possible organizing steps for every type of art and craft in one chapter would be a near impossible task. Therefore on some of these steps, you

are going to need to adapt these to the application of your specific type of art and craft, and some of these things may or not apply to your type of booth, but a great many will.

LISTS, LISTS AND *MORE LISTS!*

To minimize the possibility of forgetting something at a show, the most important place to start is with that good old basic pad of paper. *Make a list!* List out things you will need in the following categories to begin with:

Your tent set-up: What are all the things you need, just to set up a tent or awning. Do not forget your tools too! This can also include flooring for the bottom of your tent, side walls, and even awning extenders.

Your basic displays: This is anything that you will place your work on, hang from, or tie up with.

Signage: This would include point of purchase signage, big booth signs, and even small signs on each item. This includes bringing materials to make signs while you are there to adjust for conditions in the show.

Pricing information: This means price tags, stickers, labels, etc. Bring extra as you may need to make changes as the show goes along.

Your products: How many of each type, how you will transport them, etc.

Show paperwork: Every show sends you paperwork. Round up any paperwork sent to you by the festival that you are required to present when you arrive.

Money, receipt books, etc: You will need to be sure to bring money, receipt books and all the equipment you may need to accept payments from the customers. This includes back up credit card slips, and supplies in case you have to operate without power for all or a portion of the show due to unforeseen circumstances.

Personal items: These are the things you will need to be at the booth comfortably, like clothing items, hats, sunglasses, eye glasses, chairs to sit on, food, water, vitamins, etc.

Start with those basic categories, and expand upon them as you need to. These are usually the basics. There can of course be a lot more.

It is highly recommended that you make these

lists and store them where they can be safe. Keeping them on your computer, and back them up on separate storage disks or 'in the cloud' is a good way to do this. Make it so you can edit them at leisure when you are done with the show so that you make sure you include anything new you discovered you needed while at the show.

DRESS REHEARSAL

Have you ever been to a dress rehearsal at a wedding or theatrical performance? Do you know why they do this? It is to discover any unplanned for omissions in the entire package of the event! *So why should your arts and crafts booth be any different?*

Set up the entire booth in your back yard or in a public place somewhere away from the show in advance, and include everything you will need. Set up the tent, tables, displays, products, etc. Walk through it completely, and make another list of all the new things you realize you will need to set up at the show. Have some friends come by and look at it and

give you their impressions as well. Work out all the kinks in your dress rehearsal before the festival. This is a great way to make sure you do not miss anything important in the basic set up.

BACK-UP SUPPLIES

Whenever you are at a show, you will likely need back up supplies. No one wants to run out of product ever at a show. The more shows you do, the more you will be able to predict what stock you will need to bring as a back-up. You will need more product, than your booth holds for a bigger show or longer, so you will need some means to store these away from the booth. Usually with most art and craft show vendors, these items are stored in a vehicle, trailer or in your hotel room nearby the show. You will need to be able to access these supplies during the show, so the closer they are to your booth the better. As a rule of thumb, if you are not sure about the amount of supplies you need, bring at least 2 to 3 times stock of what you are going to display, and multiply that by the number of days in the show.

12 ~ Arts & Crafts Shows

So if you are at a 3 day show, anticipate you might sell everything in your booth 2X a day meaning in a worst case scenario, you need at least 6 items for every one item on display to not run out by day 3. This is no hard and fast rule, but it is a good way to start. It also depends on your point of purchase price point, and the volume of people expected at a show and how popular your products are at a show.

Also in terms of back up supplies, you should include any back up tools, tape, paper, pens, and anything else that you would be hard pressed to not have in the booth during the show.

BACK-UP PLANS FOR LOSS OF POWER

What is your back-up plan if the show loses electric power at any time? It is always wise to have a back-up plan for the event that the festival you set up at turns out not to have power for your booth, or the power goes out during the show. Some vendors bring things like electronic cash registers, and credit card machines. These things are great for speed of service to buyer, but what happens to your ability to collect money if you lose power?

One should always have a *back-up plan* in the

event one is without power during a show at the booth. I once went to a show and the vendor next to me had an electronic cash register, and he had done hundreds of shows. Along next to his cash register he had a marine battery set up which he had adapted to be able to connect to his power cord to run his cash register with it should he need to. It was set on a switch that he could turn should the show ever lose power, and he brought this as his standard back up for every show. His plan was to switch from festival power to the battery if ever the show went out, and according to him, he had to use it about three times that season already. He estimated that festival power losses happened at an average of about one out of ten shows that year for him.

Another way to prepare for this is to have the equipment on hand to allow you to function without power. So with credit card machines, for example, have a manual swiping machine or invoice pads to do hand written receipts as needed.

If your booth goes into the night, and you lose power, having some battery operated lanterns that you can hang up would also be a good thing to have as a back-up system. This would allow you to set up lights, and carry on.

In short, if anything in your booth requires power, always have a back-up plan to operate in the event that you lose that power during a show.

CHAIRS, FEET, WATER AND FOOD

As a vital preparation step, one must realize that show days can be very long days when you are at an arts and crafts show. One is up early in the morning getting set up before the show opens, and one is usually there until late at night closing up for the night, or tearing down on the final day. It is important in a chapter on show preparation to make sure you include some basics resources to help you get through.

Chairs: Chairs in a booth are important. When you are standing all day long, it helps to have at least one available even for just a quick sit down to get off your feet for a few minutes. Don't get too crazy with too many chairs, so that you compromise display space. Also, if you have a lot of people helping in your booth,

having a bunch of people sitting down with no action can work against you, which we will go into more detail later. I always recommended using the chairs to give someone a break on rotation, and always have someone standing greeting and talking to customers.

Shoes & padding: Wearing comfortable shoes at a show is vital. Make sure you acquire some extra padded insulators that you can put in your shoes; especially of you are setting up and operating on a concrete or asphalt surface. These surfaces can be very hard over the course of a day, and if one is at a three day show or longer, it can wear on you as the day's progress. Another great thing to make it easier on your feet is to buy foam rubber ½ inch exercise or play mats that are available for kids rooms, and set those up on the floor of your booth. This extra cushion to stand on can make a world of difference, and are better than carpet as they do not absorb water if you get caught in the rain.

Water: Keeping water and drinks on hand though out the show in your booth is essential. It is easy to get dehydrated without knowing it on hot days in the summer at a festival. Another trick to reduce dehydration is to have some salt and potassium tablets on hand to take as well. Vitamin B Complex also helps

as well. These will help prevent headaches from dehydration on hot days.

Food: Keep an ice chest of food in a booth. Quite often one can eat at other vendor food booths at a show, but you can also lose a lot of time leaving your booth and standing in line for food, before you get something to eat. Not eating can wear on your energy level, and make it harder to carry on with your day or deal with customers. I always recommend taking an ice chest with things you can eat quickly if your booth is slammed with people during a rush hour, such as prepared sandwiches, yogurt, fruit, energy bars, etc.

DO NOT FORGET MOTHER NATURE: PREPARING FOR WEATHER

If you are going to be doing an outdoor arts and crafts show or festival, you can never overlook the impact of Mother Nature. As a Vendor, one needs to be prepared for this above all, as one can lose a lot of product and other vital things if you are caught off guard. Talk to any

experienced vendor who does shows for several months in a row, and they will tell you that weather will cause problems with every 1 out of 3 shows on average. There is no rhyme or reason to understand it, so one must be prepared.

Let's look at some of the obvious:

Rain: Rain is the ultimate festival killer. It can come suddenly, and douse everyone and everything and drive away your customers. Usually your more organized festivals keep vendors appraised of incoming weather systems so you can be prepared. However, one can never entirely depend on that. It is better to check your own weather resources before you begin your day. Today there are so many smart phone applications that give a forecast; it is hard not to have access to that information. The best prevention against rain is to be able to cover your goods that might be exposed. Be able to quickly drag large displays back into your tent, and drop the side of your tent to prevent rain from coming in cross-wise. Also it is wise to have anything that could be sitting on the

ground not be perishable. Rain is why carrying your goods in paper boxes is usually a bad idea. It is better to keep all your things that you would need boxes in a plastic crate, or tub with a sealable lid. The good thing is that rain in the summer time frequently has a way of coming and going quickly, so hopefully when a rainstorm hits it is not a disaster for your show, and the sun comes out a short time later restoring the life again.

Wind: If you have ever been at a show during a windy day, it can also be a problem. Mother Nature on a windy day can knock over tents, displays and all kinds of products at an arts and craft show. Vendors need to prepare for this eventuality with weights of all kinds for their booth and displays. One needs weights for all four corners of the booth. A great way to do this is to bring along a cinder block for each corner, and tie is down when you set up. Or if you are on grass, stake each corner of your booth down and use tent ropes too. Another great corner weight is to take some 3 inch PVC pipe from the hardware store, and cut it in 4 foot lengths and fill them with sand, rocks or concrete and cap each

end. Then screw in an eye hook, and hang these on each corner of the booth. On displays, sand bag weights, rocks, and tie down chains to tables and heavier things in your booth are a good way to counteract the effect of wind. Wind also likes to throw over signage too, so with large signs have them cut with little slits or 'wind holes' so that they do not become a kite under heavy wind conditions.

Heat: Sometimes the temperature can go up in the middle of the day at a festival and make it uncomfortable for all in attendance. Some tricks to help with this are to have fans placed in the upper corners of your booth to circulate the air. It may even help draw customers into your booth too. Give away free bottles of cold water to customers, or sell them for a dollar to draw traffic, depending on what your festival rules will allow. If you have clothing products, adjust your displays to focus on products such as hats, sunglasses and fans on hot days. Wear a hat yourself if you are going to be in the sun a lot, it really helps.

Cold: Sometimes in early spring or later fall shows the temperature can drop unexpectedly at a show. If you checked your weather forecast in advance you can bring a jacket, etc. However, this can also be a great way to adjust your product sales if you are selling clothing to warmer items like scarves, and gloves. Serving hot cocoa or cider also is a great thing to plan for to get people at your booth if you think the weather might turn cold.

Insects: On occasion at an outdoor show, one might find that they have to deal with insects that create annoyance throughout the day or part of the day. Mosquitoes, gnats, bees, wasps, ants, etc. can really make life miserable at a show if you have to deal with a lot of them. Keeping in your supplies insect repellants you can wear, and a can or wasp spray is

always a good idea. Keep food refuse out and away from the booth as well. There are also some small fan blower units that you can buy from camping supply stores that blow insect repellant that you can set up in the booth. Check with your outdoor camping supply stores for other products that might be available to help with this too, as there are always new products coming out. Electric bug lamps can also be helpful for night vending booths.

GENERAL SUPPLIES & FIRST AID

There are always some general supplies that one needs at a booth. String, duct tape, scissors, price tags, paper, pens, markers, brooms, rags, trash bags, etc. One should make a special list of these smaller items. Be sure to include a first aid kit as well. Things in the first aid kit should include band aids, hand cleaners, salt tablets, insect bite remedies, and sun screen. Make sure you have a card filled out on everyone who works in the booth on who to contact in case of an emergency. If anyone working the booth with you is on medication, make sure these items are accessible as well.

CALENDARS, SCHEDULING AND FESTIVAL PAPERWORK

In order to participate in an arts and crafts show or festival, one needs to first submit an application usually for that show. Then once your application is approved, and you have paid your booth fee, you need to mark it on your calendar, and begin preparations. Usually a festival will send you paperwork for your registration when you arrive to set up. Make sure you place this with your vital things that you need to bring to the show with you.

GIVING OTHERS ADVANCED NOTICE

Do you have prior customers in the area of the show you are going to? Have you sent them a notice letting them know you will be at that show again? This will be covered more in a later chapter, but it is an important thing to note on your preparations list. Be sure to give advanced notice to anyone you know in the area that you will be at the show.

Lessons from this chapter to remember:

- *Be prepared.*
- *Organize with lists.*

- *Prepare for Mother Nature.*
- *Bring your festival paperwork.*

24 ~ Arts & Crafts Shows

~ Mistake #2 ~

Booth Basics Missing

The next major mistake one can make as an art and crafts show vendor is to not know some basics about your booth and set up. Booths at most art and craft shows require a tent or awning if you are outdoors. If one is indoors, one can forgo a tent or awning if you wish, but outdoors if the show is any longer than a few hours you will usually need one.

TENTS OR AWNINGS

I have attended many arts and crafts shows where vendors believe they can do the two day show without a tent or awning, and that by looking at the sky they can

predict the weather, etc. This is courting disaster, and it is a violation of the understanding of booth basics.

Having a tent or awning does not just protect you from weather and the elements. It gives your booth height that it otherwise does not have. Height is important in an arts and crafts show. Booths are often placed side by side, and quite often your neighbor has a tent or awning. Having one yourself gives you the ability to hang your signage up higher, and thus create more visibility with the attendees at a show.

Tents or awnings also give a sense of having a store front, or location, even though it is temporary. It is easy to use as a point of reference, and if you are there at a show more than a single day one can close it all in and button it all up for the night to enclose your displays and products until morning. Most festivals that are overnight offer security, so having a tent one can zip up and enclose at the end of the day offers an additional measure of security overnight.

One can either buy a tent or awning or rent one. If you are unsure of which design of tent will work best for

you, I would suggest you rent one for the first couple of shows and also look at the brands other vendors use until you find one that you will want to invest in and purchase. Most tent designs collapse into an easily portable size, and some are heavier than others. Some are simple, and some are complex. They usually break down into two basic structural designs: *ones with separating poles*, and ones with *an accordion-like collapsing frame*. Examine both to find the one you are most comfortable with purchasing, as the prices will vary.

SIGNAGE

The next thing that is sometimes omitted in booth basics is signage. Believe it or not, lack of signage can do more damage than good. Signage should be placed at different heights so as to be visible, and also pointed in both directions for the flow of body traffic at the show. There should also be smaller signs communicating different things about your products. Sometimes you want to show dimensions, define the material that is in the product and

the size if it is a clothing item for example. However, this signage also needs to communicate the price. Assume from the prospective buyers viewpoint anything that they may not know about the product at first glance may need to be communicated with signage.

Signage should be simple, readable and direct communications that someone can grasp upon first glance, because that may be all you ever get. Signs act as a method to draw people to a booth or product, and capture their attention. The best test for any sign is *Is it readable from 10 feet away?* and *Is the message clear?*

DISPLAYS

You will need displays in a booth. It is not enough to just set up a table and lay everything flat and hope that people walking by will notice it. You need to have racks for clothing items. If selling jewelry, you will need things to hang them up on or maybe even a mannequin head or other type display that communicates and draws people to the booth. If it is paintings or any other kind of flat displaying art, you will need easels or some other upright display. Avoid laying items flat on a table

as your only display. Flat laying items are not eye-catching from a distance, so always have them set up at an angle so they can be seen.

BACK OF THE BOOTH

In some shows if there is traffic on both the front and back of your booth, you might need to make sure your signage and displays are adequate to draw business from both sides. This would also go the same for a corner booth, or one on the end of a row. Make sure your display factors in the direction that the traffic of people will be flowing in front of the booth.

DISCOUNTS AND SHOW SPECIALS

People coming to an arts and crafts show are quite often just looking. In order to help your sales, and take them from a 'just looking' customer to a 'buying' customer, it helps to have some show specials. If you are doing a multiday show, you can try a different one each day if you wish. Also offering a discount package for multiple purchases is also very useful to promote more sales, and customers like that and often look

for it at a show. So if you do not have this, you might be losing sales. Work out a plan to offer discounts for multiple purchases, or a show 'special' item or a *'free gift with ____ purchase'* or something of the sort.

PROVIDING CONTACT INFORMATION

A thing a lot of vendors forget to include in their booths is business cards. You need to have a supply of those at a show. If not, then get some flyers of slips or paper at least printed up with your name and business on it to give them when they make a purchase. Make sure you give them out with every purchase! Also make sure your contact information is printed on every receipt as well. These items may cost some money in printing, but there are a lot of inexpensive ways to do this, and the return response from a customer who calls you months later looking for another piece is invaluable.

MANNING YOUR BOOTH

If you are going to be doing a show for several days, you are going to need to man the booth the entire time. One would think this does not need to be said, but you will be surprised how many times one can attend a

show and see a booth closed up or unmanned because of no one to staff it. The minimum for most shows is at least one person. No one visits a booth that is empty. If you are going to sell larger items, you better have two people. This would also be the case for high quantities of smaller items to account for times when you have a large crowd gathering. Leaving your booth unmanned during show hours can also result in you being banned by festival organizers as a vendor in that show in the future.

BOOTH SET UP FOR MANAGED FLOW OF TRAFFIC

Let's not forget that the basic set up you have for your booth depend on how you set up the basic layout when you start. A booth layout will provide a means in which to manage the

flow of traffic.

Consider the following designs of basic booth layout for a standard 10 X 10 arts and crafts show booth. One must of course factor in the type of products one is selling in order to determine the best design for their use. Some of these layouts will work well for certain products, and others will not. You will want to be careful of creating a bottleneck of body traffic in your booth, as that can hurt business. More on that subject will be covered later.

In the following designs 'P' stands for the *'Point of Purchase'* area where you will conduct sales, etc. The 'T' refers to a *'Table Display'* and the 'W' refers to items that are hanging or a *'Wall hanging'* display in your booth. The 'D' stands for some kind of *'Display'.* The arrows represent the projected flow of body traffic. Remember these are common examples, and there can be many variations on a booth layout. What is important is that you choose the one that will give the best flow of traffic for you.

The first is the most common booth style, which could best be described as *'side by side'* where you have vendors on both sides, and essentially only one open front.

Side by Side Booth Layout A:

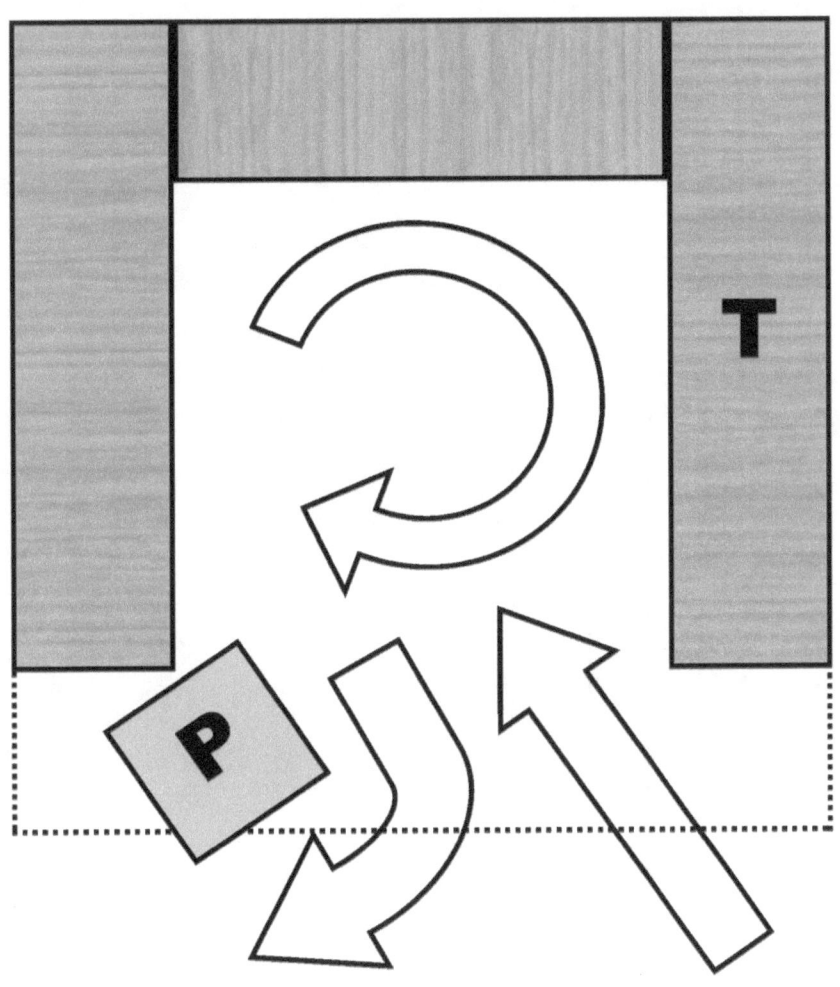

34 ~ Arts & Crafts Shows

Side by Side Booth Layout B:

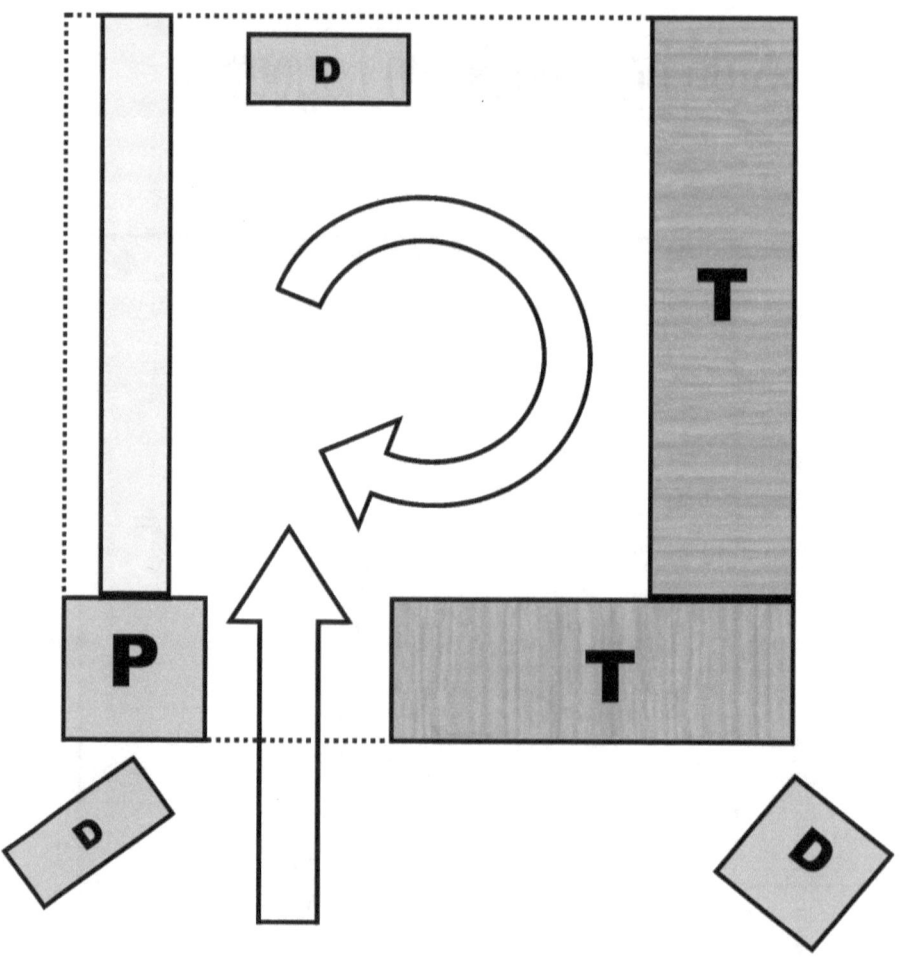

Side by Side Booth Layout C:

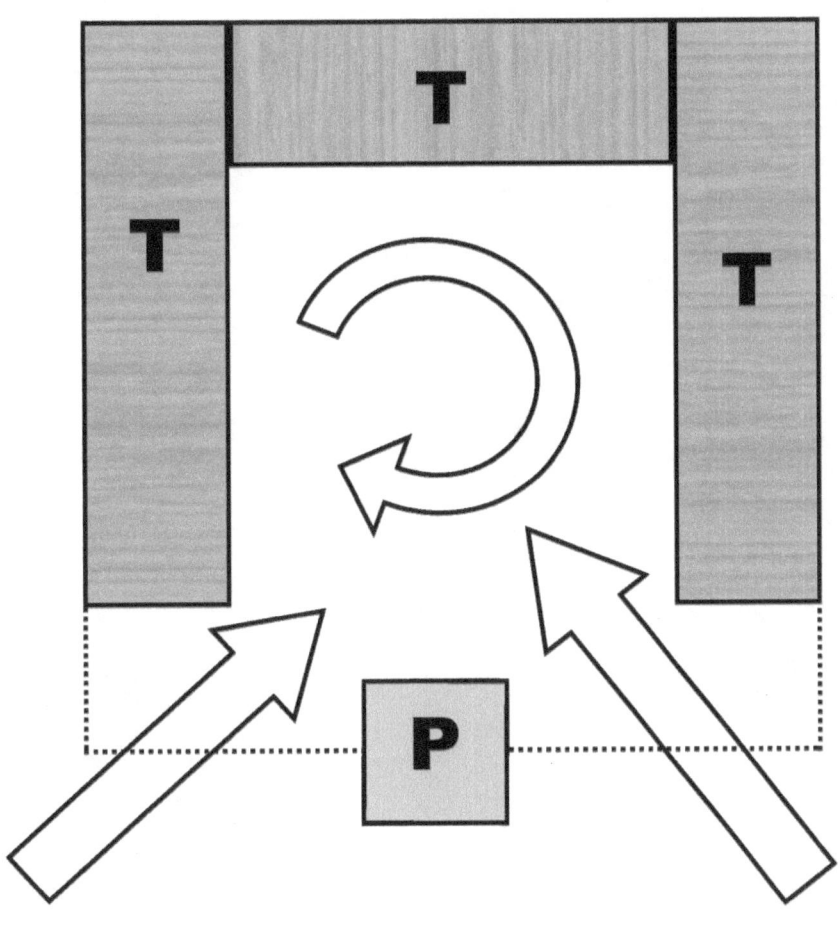

36 ~ Arts & Crafts Shows

Side by Side Booth Layout D:

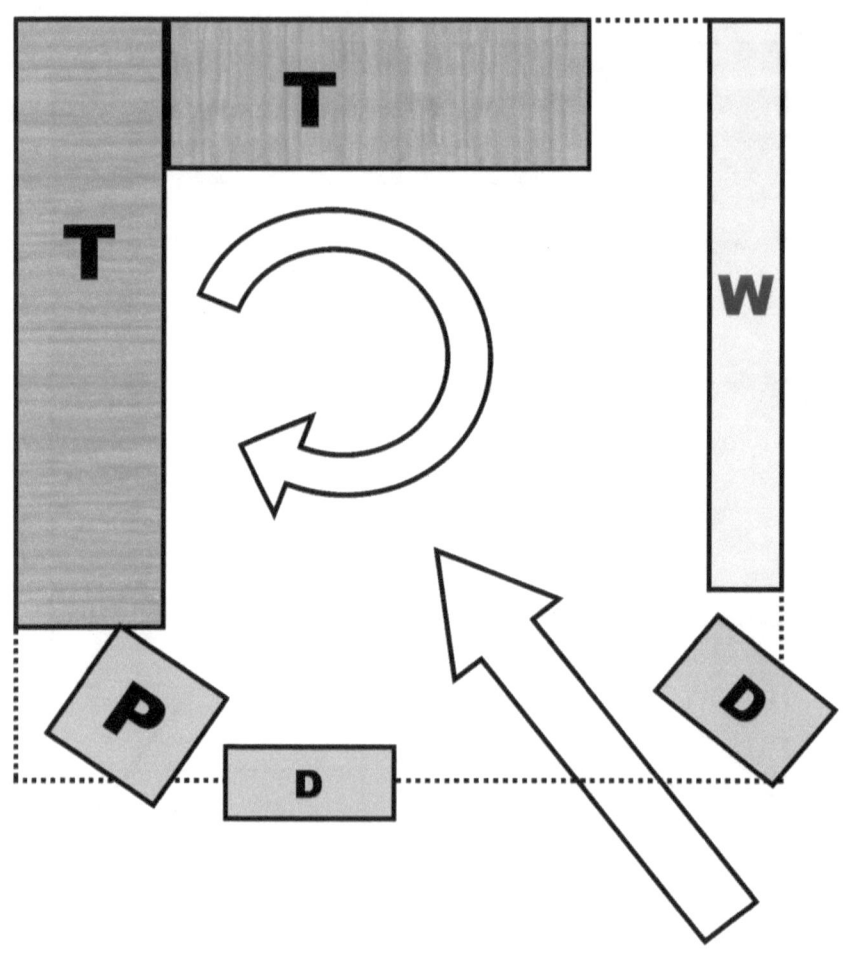

Side by Side Booth Layout E:

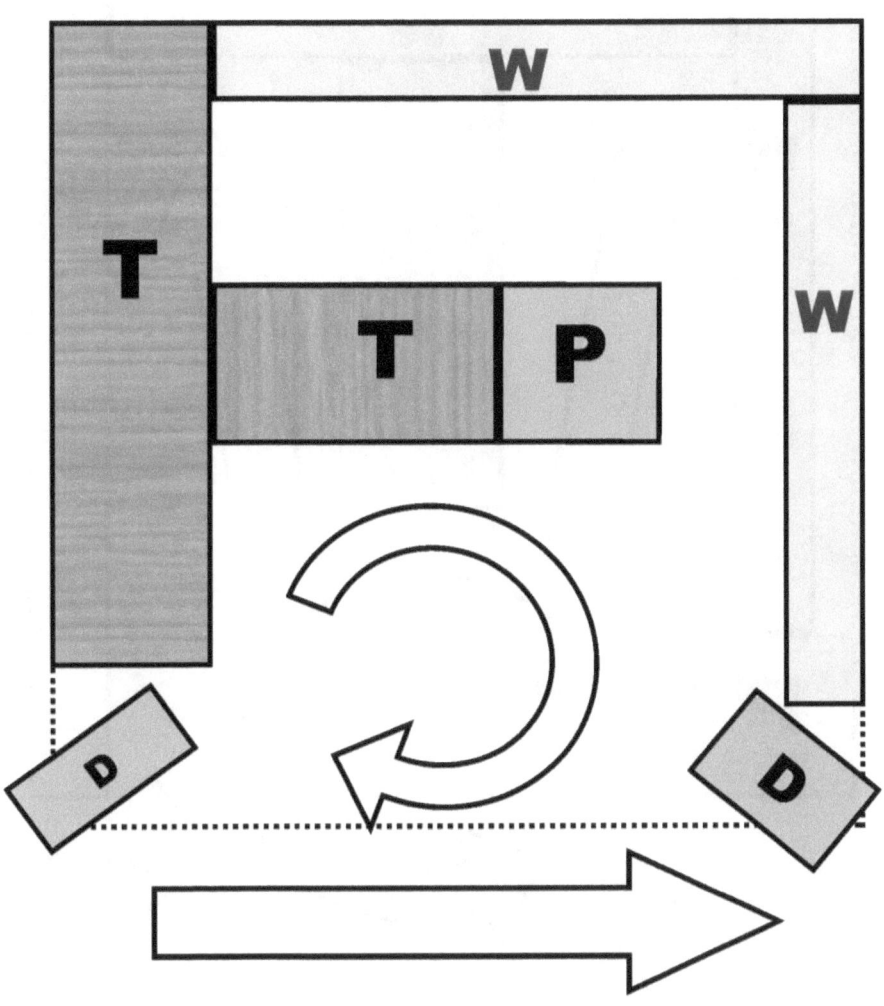

Side by Side Booth Layout F:

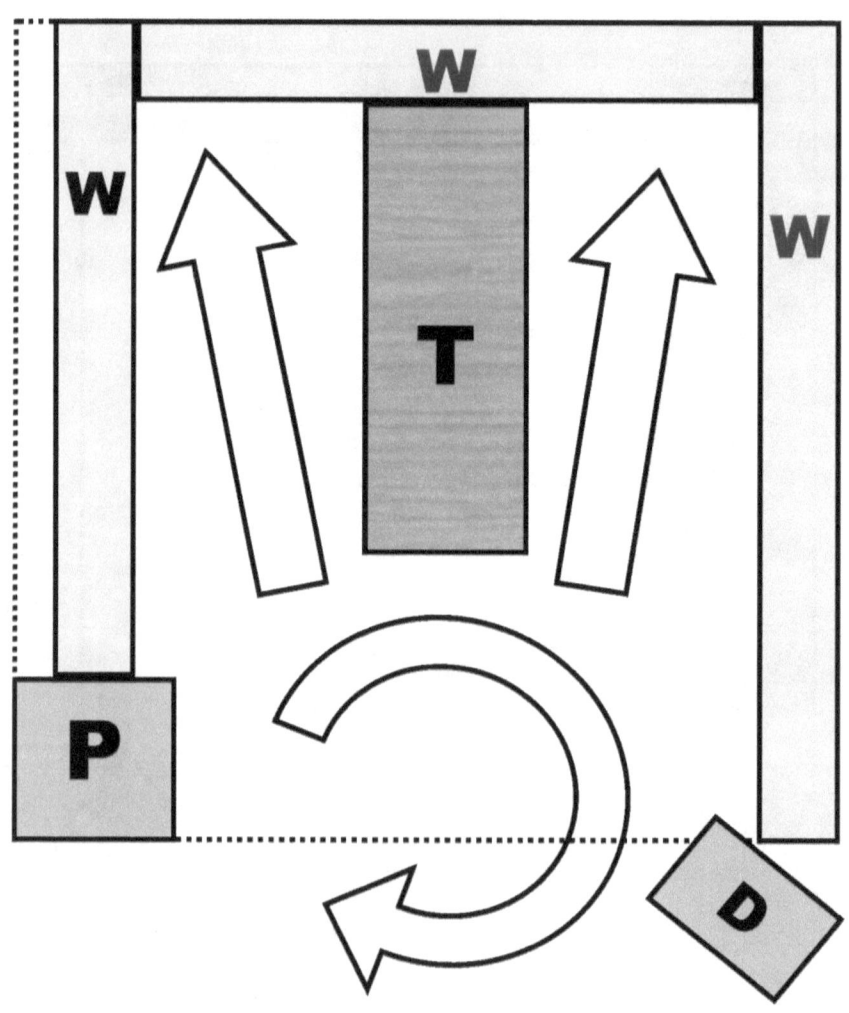

Arts & Crafts Shows ~ 39

This next is the *corner booth design*.

Corner Booth Layout A:

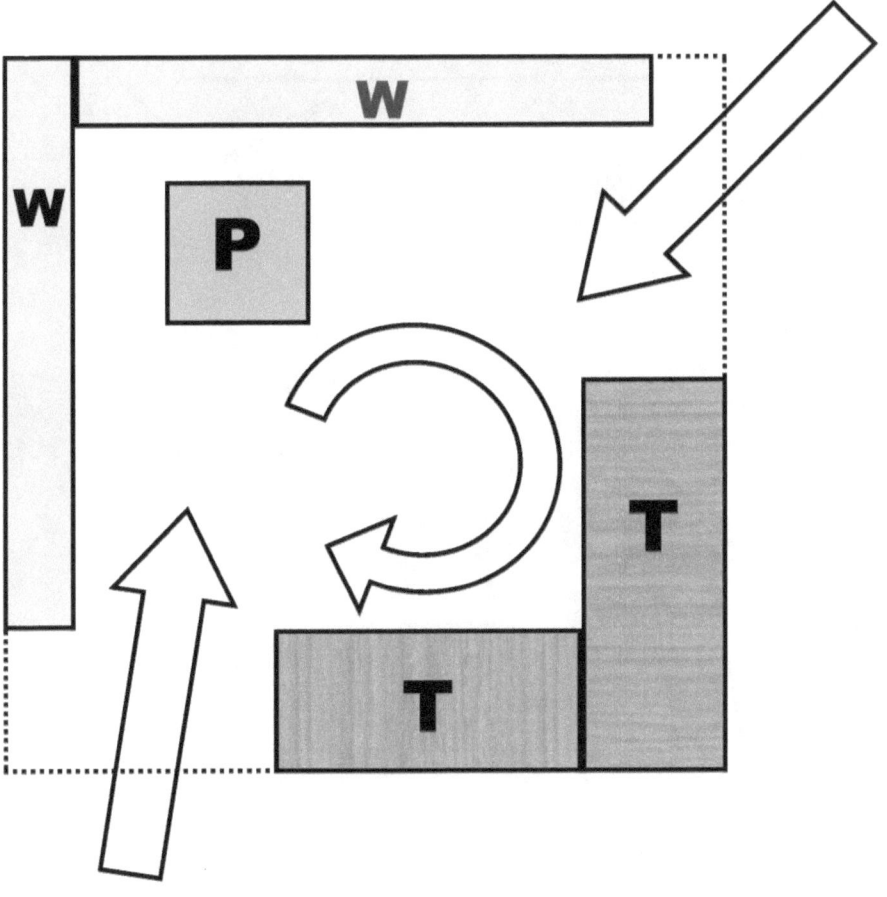

40 ~ Arts & Crafts Shows

Corner Booth Layout B:

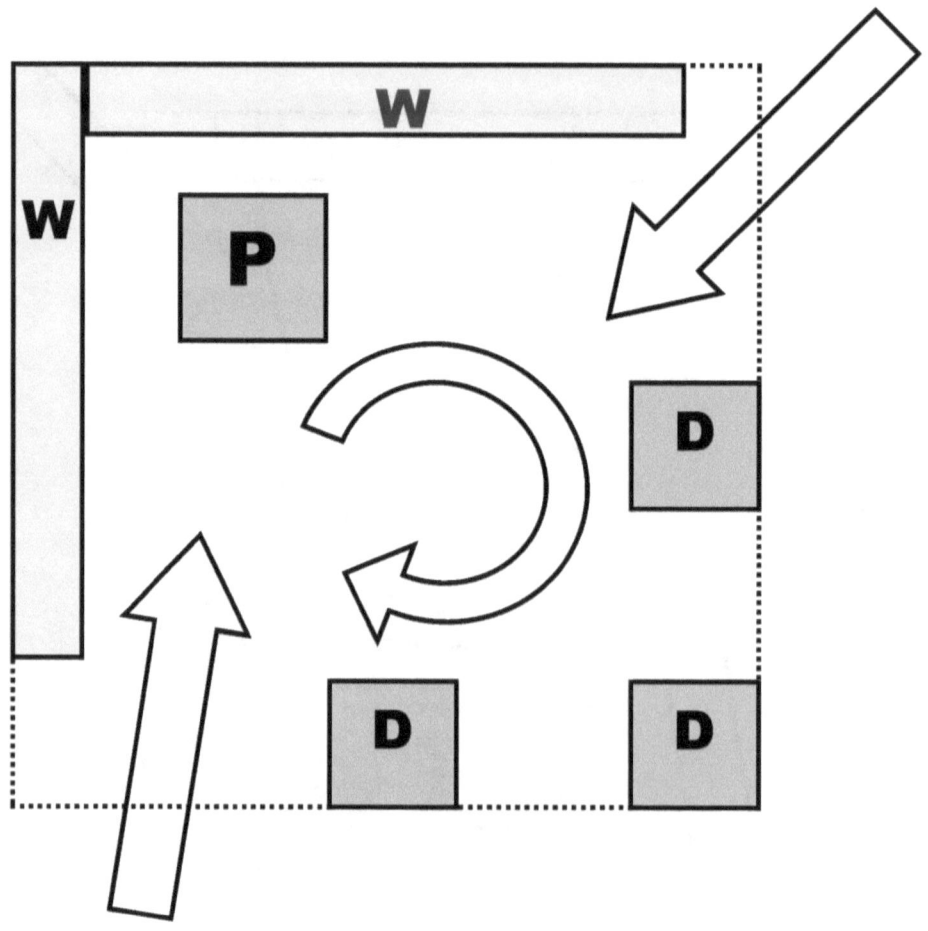

Corner Booth Layout C:

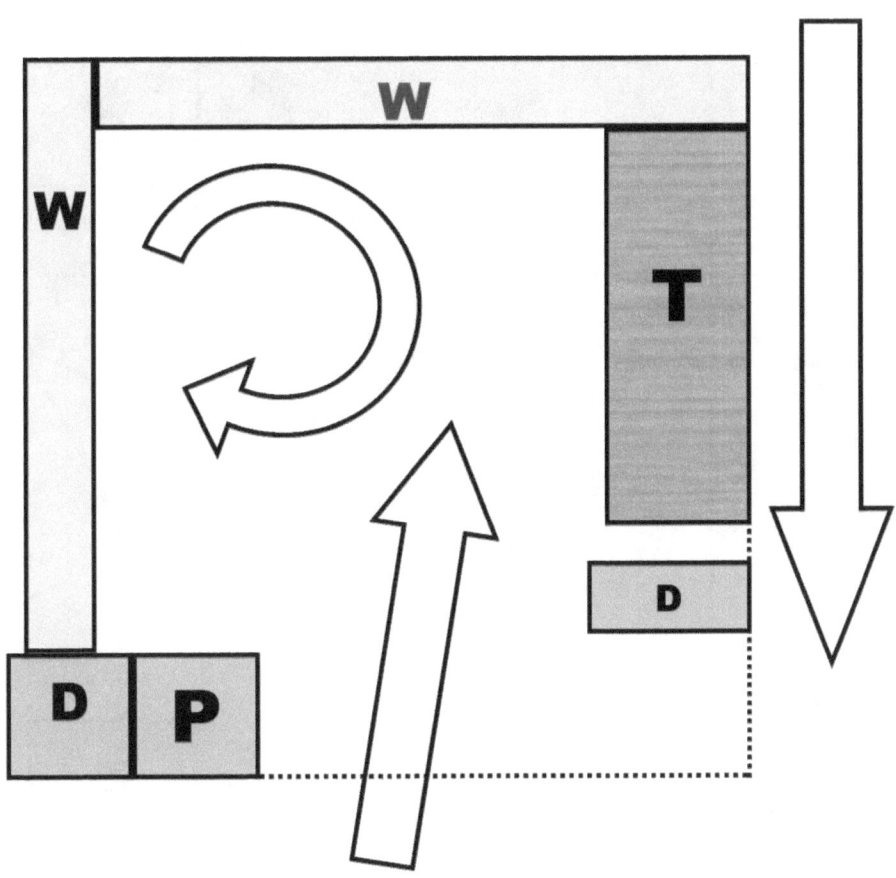

Corner Booth Layout D:

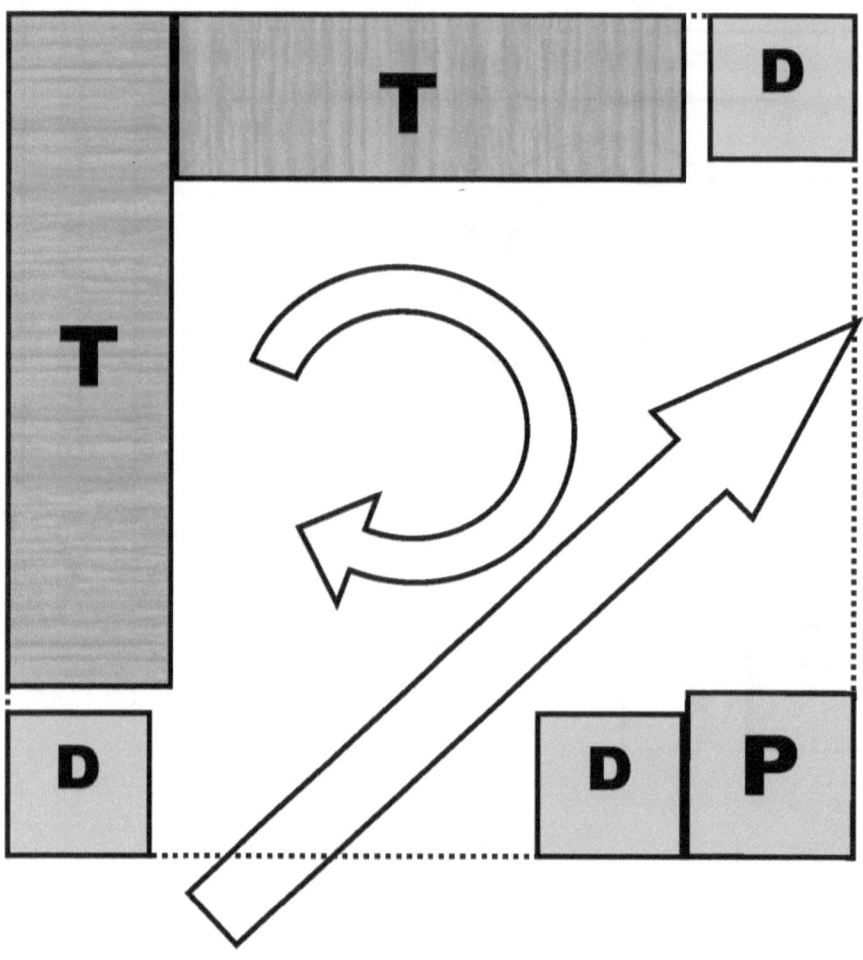

This next is for booths on the *end of a row*, where body traffic passes on three sides:

End Row Booth Layout A:

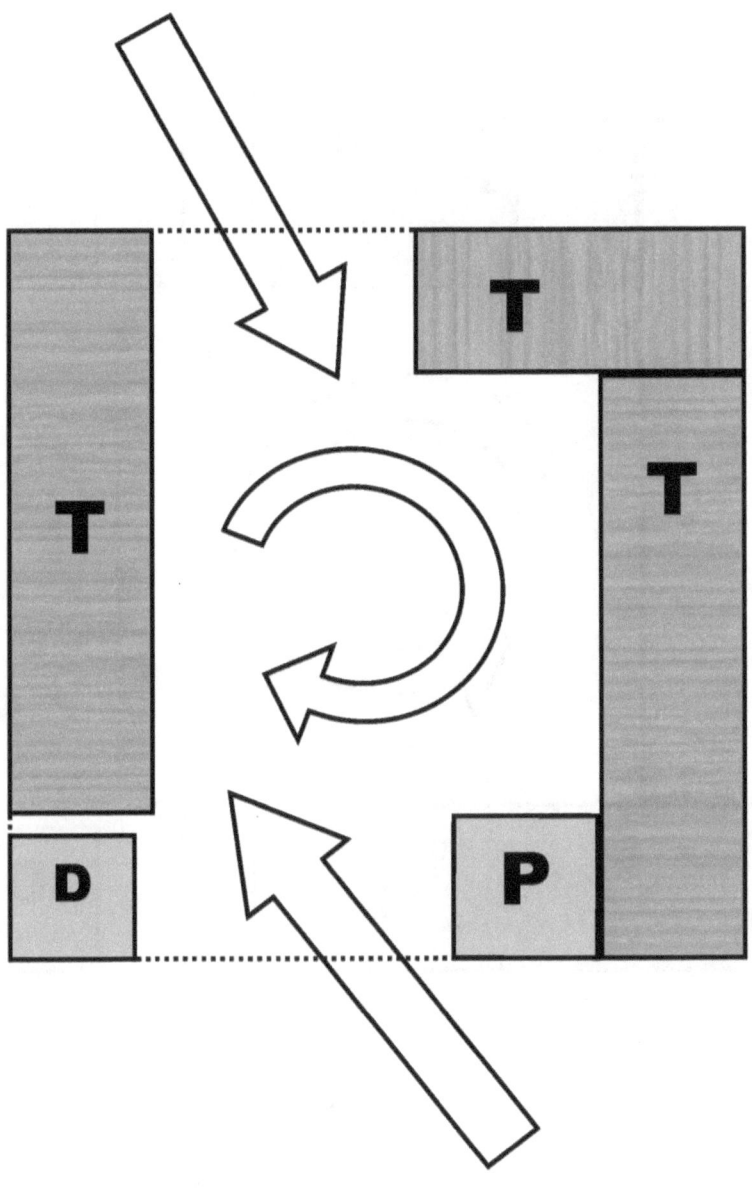

End Row Booth Layout B:

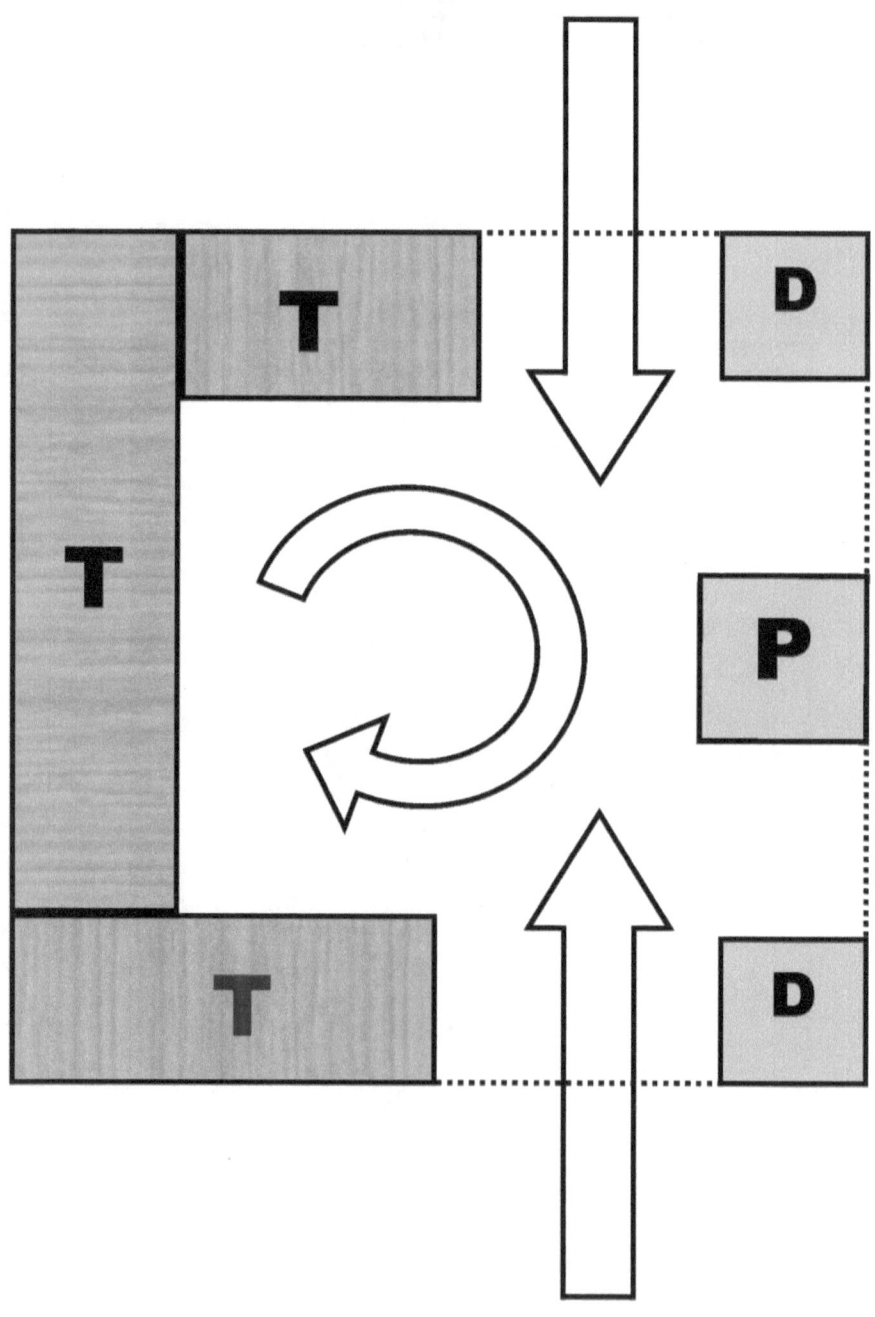

End Row Booth Layout C:

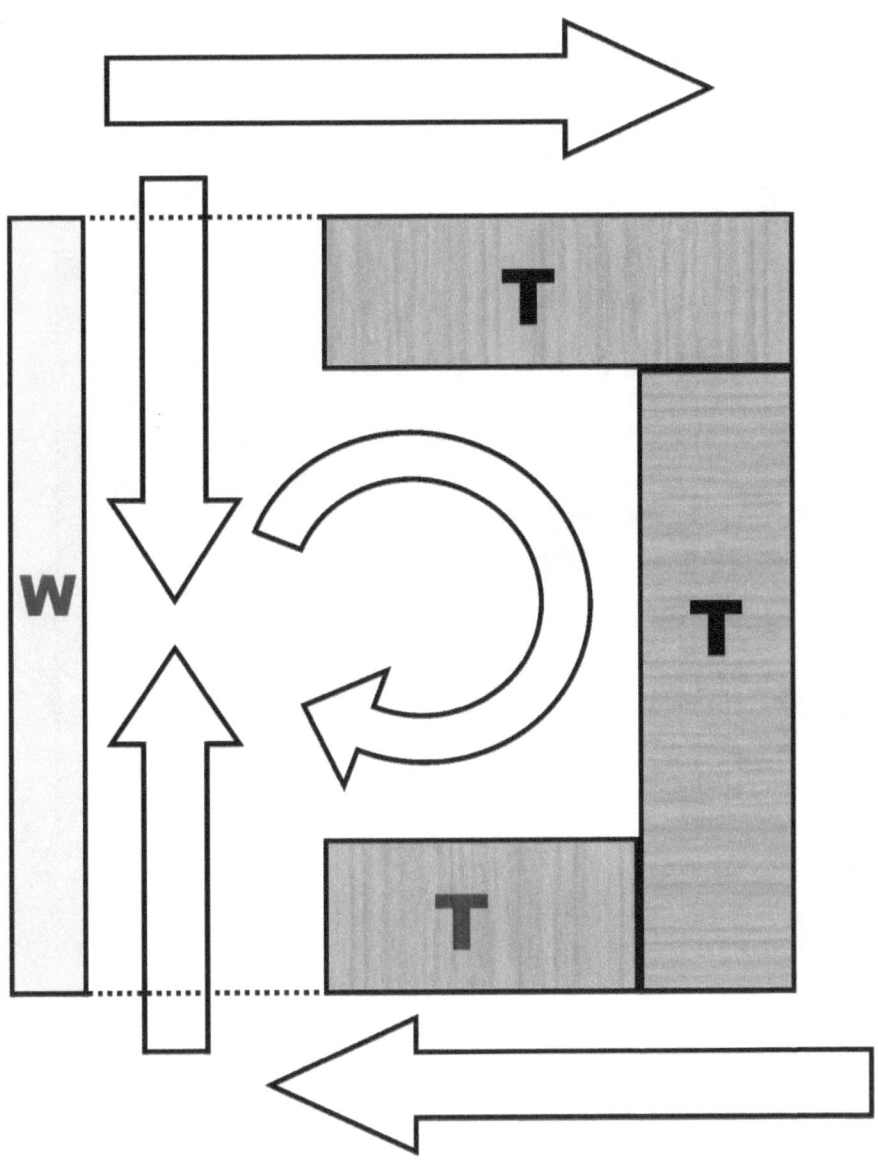

46 ~ Arts & Crafts Shows

End Row Booth Layout D:

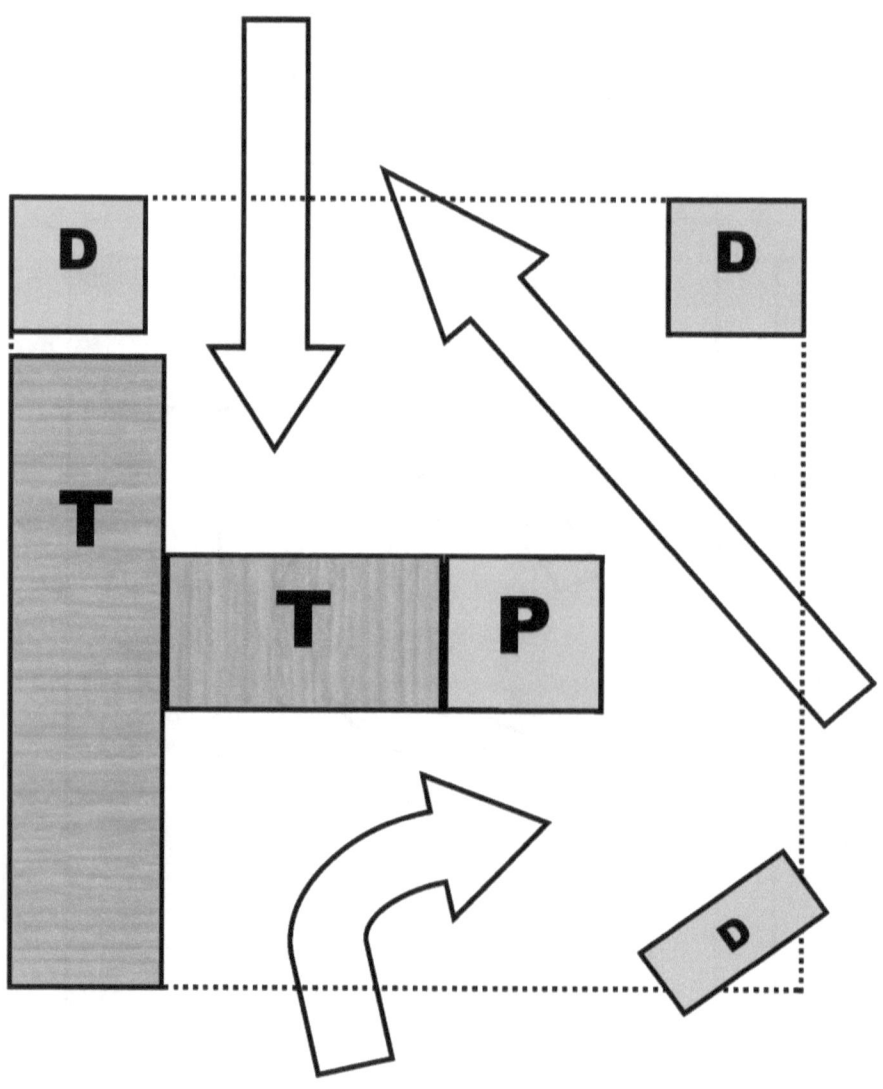

End Row Booth Layout E:

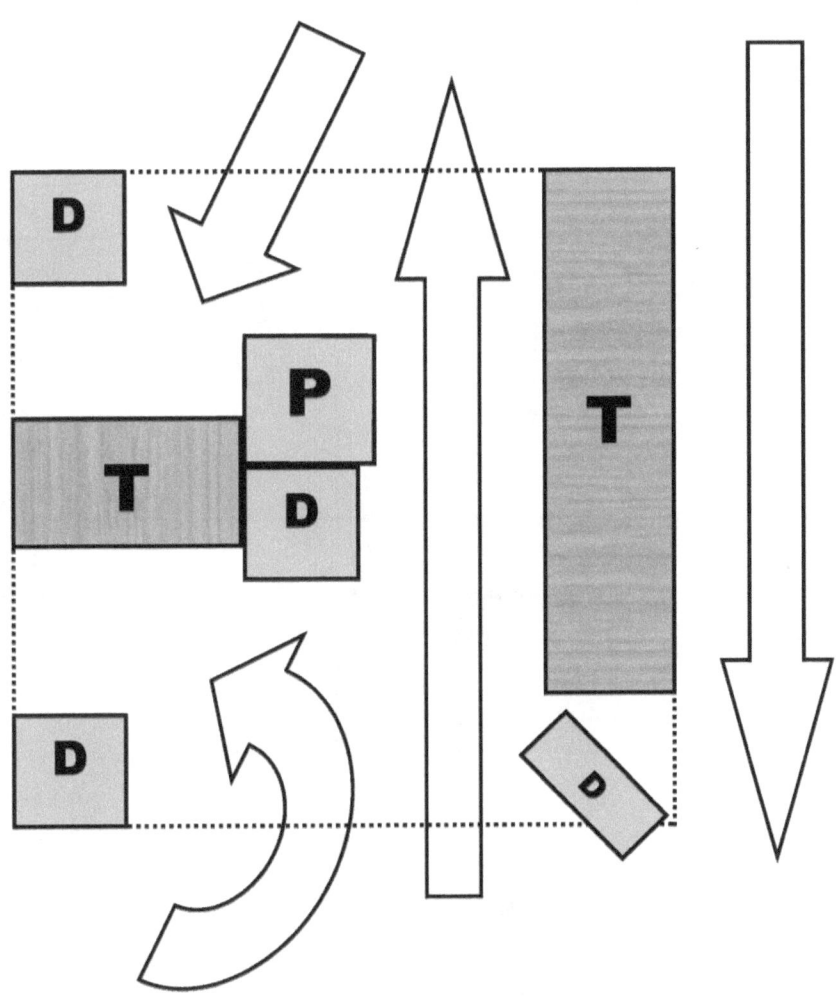

48 ~ Arts & Crafts Shows

This last is for the *kiosk* or *island* style booth, where one has body traffic coming from all four sides:

Island Booth Layout A:

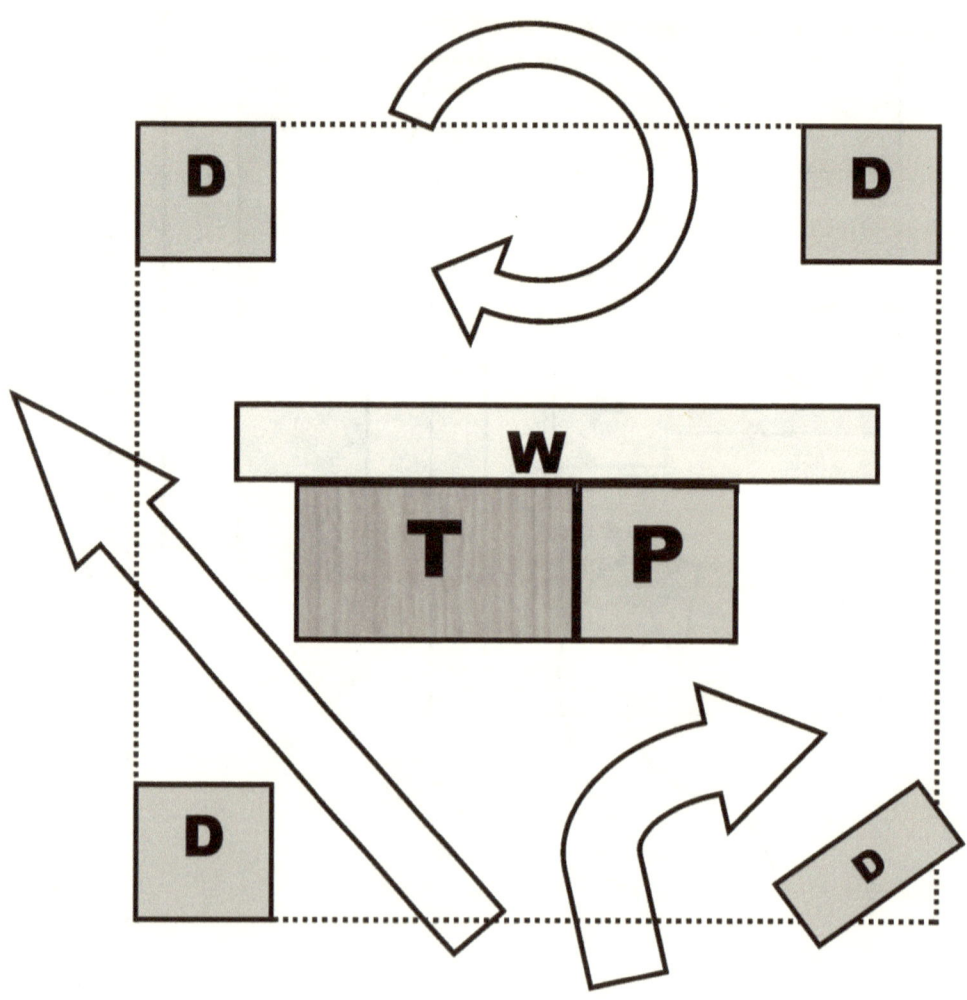

Island Booth Layout B:

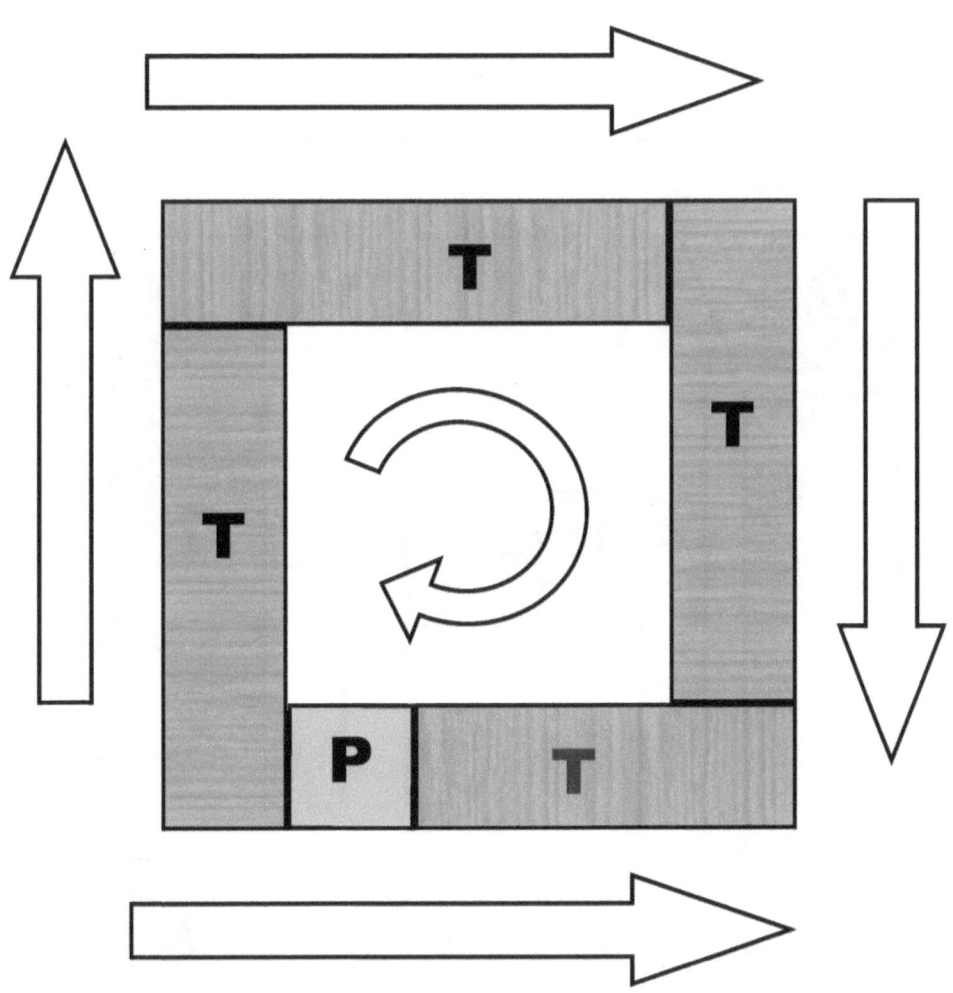

50 ~ Arts & Crafts Shows

Island Booth Layout C:

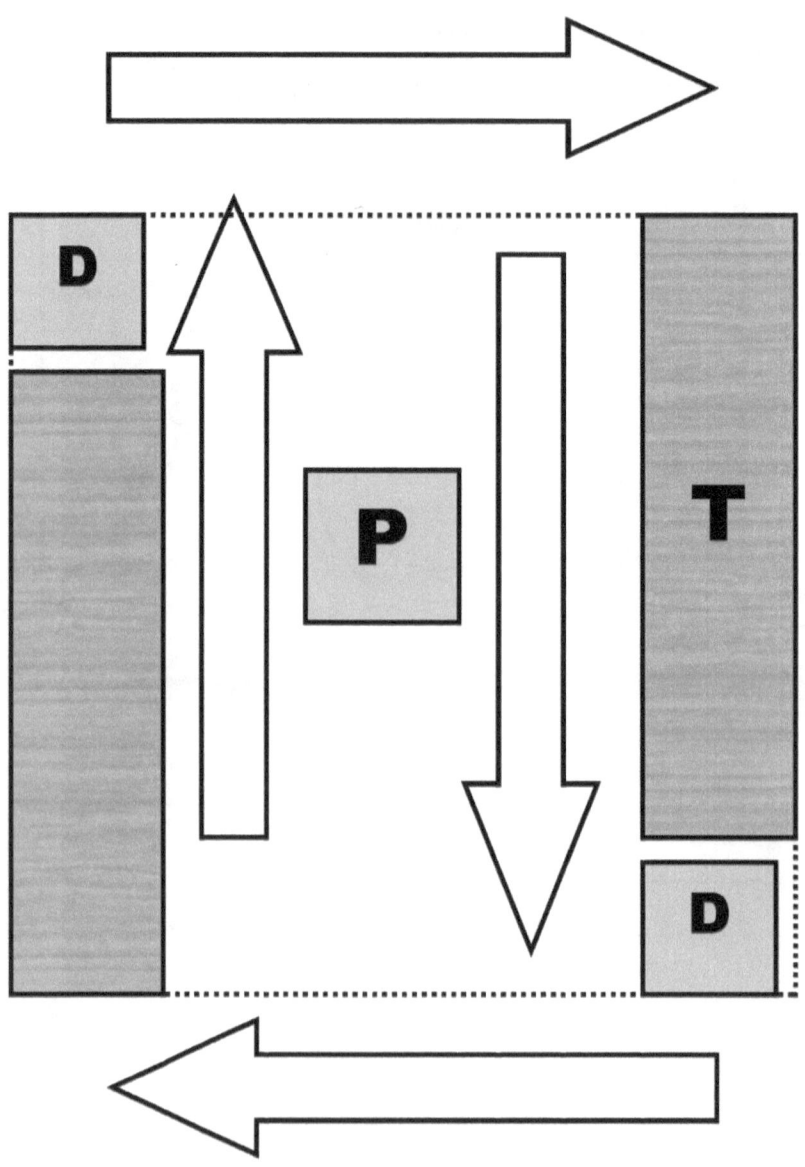

Island Booth Layout D:

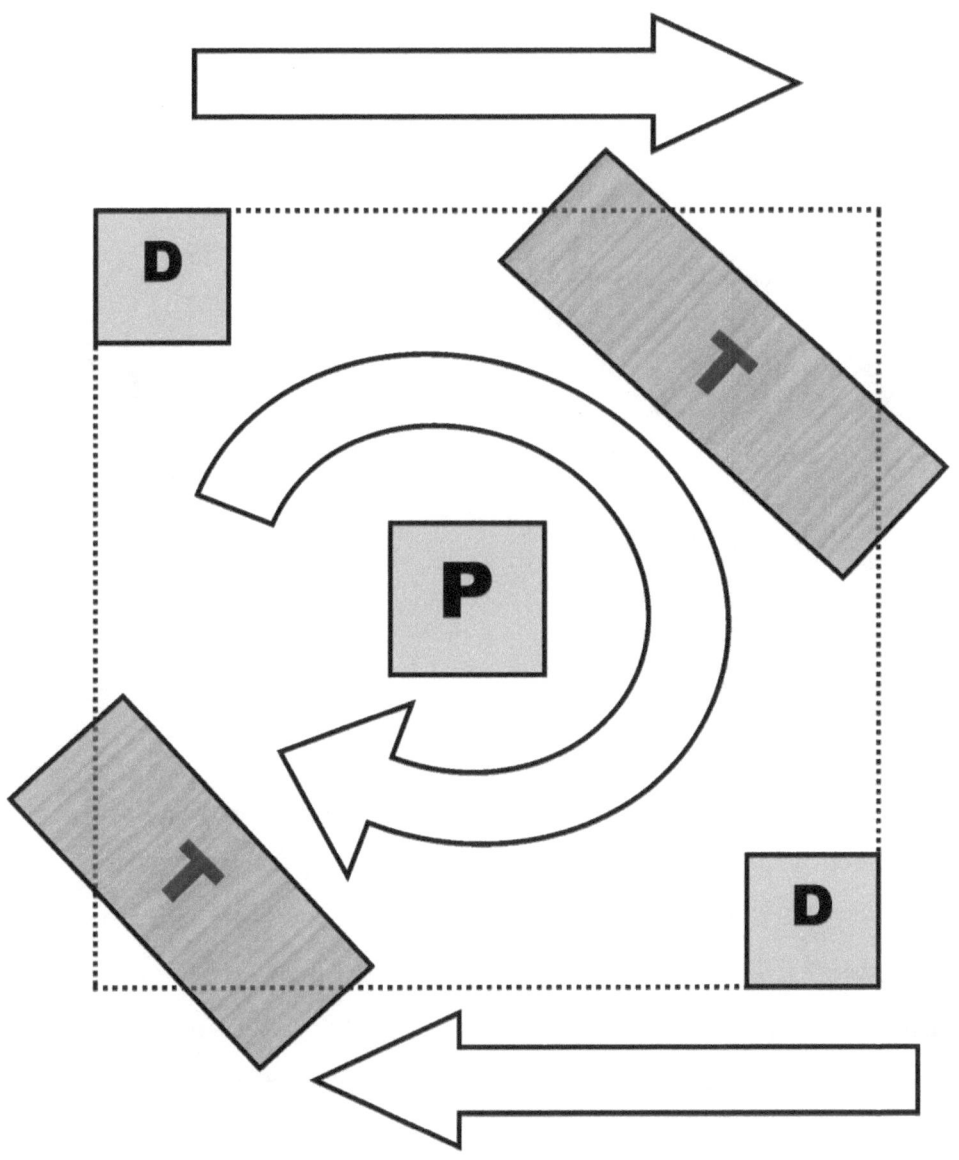

Island Booth Layout E:

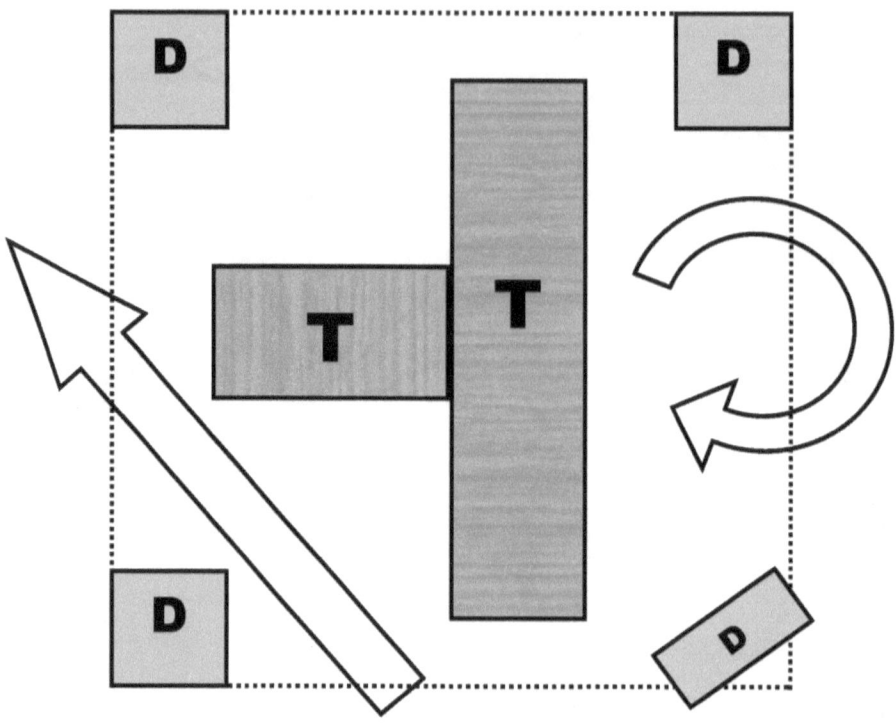

There can be many variations on booth layout, but these examples are ones that factor in the flow of traffic, visibility of displays and effective locations for a point of purchase and place to offer promotional materials, collect business cards and sell smaller items when bagging or wrapping up a customer's purchase.

HELPING CUSTOMERS WITH LARGER ITEMS

Sometimes a buyer of a large item need help

carrying the item to their car, and it becomes a condition of their buying it. Are you going to pass up a sale because you have not prepared for this contingency? Are you going to leave your booth unmanned to go carry it all by yourself? This is where advanced planning comes in. I suggest having someone working the booth that is up to this task of carrying or helping a customer carry an item. There can be long walks to a parking area as many outdoor shows, and one often has to navigate through a crowd of people in doing so. If you cannot help with a carrying something for a buyer, then you better have an arrangement for them to pick it up after the show or arrange some kind of later delivery for them. Sometimes festival organizers have volunteers that help with this too. Be sure to find out, and keep their contact information in your booth in case you need it.

PORTABILITY OF ITEMS SOLD & BAGS

People who attend shows often do not want to carry items around. If your item is large and cumbersome, offer to make the sale and tag it with their name on it and let them come back and get it later. If you do this, be sure to take down a phone number and address so you can contact them later if they forget to return for it.

Some items are easy to carry, or put in a purse, so you have no problems selling these with simple packaging. However, if you are going to survive in selling medium to large items that can be carried, including clothing, then you better provide something for them to carry it around with them or they will pass on the sale because they do not want the burden.

It has been my experience that when someone says 'I will come back later' you have a 1 in 3 chance that they in fact will. So if you want to improve your sales, provide a bag. As another note, bags can be a good promotion at a show as well. If you give away as a free

gift a really cool bag with your name and product on it, other people will see customers carrying it around the show and want to seek you out.

So in this chapter, the key lessons we learned are:

- *Invest in a tent or awning.*
- *Remember to have good signage and displays.*
- *Be conscious of your booth set up, and managing the flow of traffic.*
- *Do not forget the back or sides of your booth.*
- *Offer discounts or show specials.*
- *Give out your contact information with every purchase minimum.*
- *Man your booth!*
- *Have a plan to help customers with larger items.*
- *Make your items portable or have a system where they can buy and come back for it*

56 ~ Arts & Crafts Shows

later.

- *Bags are good!*

~ Mistake #3 ~

Inactive Instead of Proactive Selling

One of the biggest mistakes I see vendors make at an arts and craft show is that they take the 'inactive' approach. What is the *inactive approach*? It is sitting there on a chair in the back of the booth waiting for the customers to wander in to buy something. This kind approach might work for a flea market where the prospective customers are expecting to wander and sift through piles of junk on a table, but at an arts and craft show if you want to be successful, do not make this mistake! Get out

of your chair and talk to people!

Artists who practice 'inactive' selling are killing their sales by as much as 40% or more. So what is the better approach? *Proactive selling of course!* How does one go about setting up a proactive selling approach in their booth? *Get off your butt! Talk to people! Demonstrate your product! Move around!*

Let's take a look at a few examples of approaches used by some vendors I have observed, and some for booths that I have personally worked in at shows.

The painter - There are many arts and craft shows one can go to and see paintings at. If you look at the booths that in the category of painters that draw the most crowds, it is the one that actually has an artist painting a piece of work right there in the booth as a demonstration! This is proactive selling in its finest! This approach works best with two people manning the booth at least. One artist painting and other talking to customers and making sales, as people will usually be interested in buying. Have some

of the same paintings that are being produced right there be available for sale is what works best, but it is not necessary. This also works great for a portrait sketch artist, where a subject can pay right there and have their portrait done. Set appointments, or take numbers, but this is an awesome way to sell work and it is *proactive!*

The jewelry seller - Artists who sell jewelry do best when they allow customers to try on the jewelry right there. Have mirrors set up in the booth so they can see how it looks on themselves in the mirror works best. Call people over to the booth if you are slow, and ask them to try something on. Be on your feet over the table of your product, and invite the passersby to step into your booth and try on some jewelry. You should also be wearing the jewelry yourself that you are selling. Consider offering multiple item discounts, as this always works well for jewelry sales.

The clothing seller - When you are an artist that creates custom clothing, you not only need mirrors, you

need to invite people over to try on the items. Make it easy to do so. Place clothing racks and mirrors where people can easily get to them, and stand near them passing out complements and giving out color advice. I once saw a booth where they had a lady sitting customers down at a table with color charts and samples going through a color selection process with customers to help them choose the right color for their complexion, hair color, etc. Be sure to wear the items you are selling too.

The birdhouse man ~ I was at a show where a man who sold custom birdhouses had a table set up in his booth for kids to come in and paint their own birdhouses. He had several high end birdhouses he was selling too, but he had some smaller ones he sold that were unpainted. Then for the purchase of the birdhouse, kids could come in and paint their own birdhouse at a table he had set up. This is incredibly creative proactive selling, and he had a line at his booth all day. He eventually had to set a timer for each child, to allow others to take their turn at the table. It was one

of the most fun booths around the show.

Woodworks seller ~ A woodworker who was selling wooden signage also created items for kids. He made wooden rubber band guns, toy trains and other wooden toys that made all the kids draw their parents to the booth. He even had a small shooting range set up in his booth to keep the kids busy while the parents looked at his other products too.

Map Selling ~ I worked a few shows selling maps of the local regions adventures and things to do. We set up easels with laminated framed maps and a red '*You are here*' arrow on the map and used them as talking points about all the features on the maps. We stood back and as someone approached the map, we began pointing out things to them that we had on it: *Hiking trails, trout streams, restaurants, points of interest, campgrounds, etc.* After a few minutes they would ask '*How much are they?*' and we usually made a sale, sometimes more than one. The maps were awesome in themselves, but a casual observer needed to be indoctrinated into how awesome they were, and we made 95% of our sales in those shows from being

proactive and talking to people, *over and over again*.

The Baker: I once was at a show where a vendor was selling culinary creations. They were mainly selling specialty breads. They set up a small oven and baked cinnamon bread all day, and placed fans to blow the smell into the crowd of passersby. They had a line in front of their booth buying bread all day long, and were continually resupplying their booth with loaves of bread from their supply van every hour of the entire show.

Christmas items: I once manned a one day booth indoors at a Christmas show. I was selling blown glass Christmas ornaments and glass bubbles with snow inside. Every person who walked by my booth I invited to touch the balls, feel them in their hands, and shake the snowflakes in the bubbles. There were ladies who were manning a booth directly across from me selling quilts that were annoyed that I was talking to every customer, but after the show they discovered they had made only one sale and I had sold out my entire inventory. This was a good demonstration between proactive versus inactive selling.

The Music Man: A show I worked at in North Carolina had a booth next to me with a man selling CD's of his dulcimer music and other guitar solos, etc. He sat in his booth all day long giving music lessons and demonstrations, and sold his CD's over and over again. His approach was very proactive, and people loved it.

So what can any vendor take from this chapter about proactive selling? That it is *active and moving*. It is using methods to distinguish you and your products from every other booth in the show. It is offering something others do not, and it is not sitting on your butt.

So here is a list of tips for any artist to review and incorporate into their style of booth and approach to selling to make it more proactive:

- *Talk to people.*
- *Create things for people to touch and feel.*
- *Ask people to try the product on for size.*
- *Show the people how it looks in their hands,*

on their person, etc.

- *Explain the product to them, and invite them to come closer to see it.*

- *Create the product in front of their eyes, and dazzle them into buying.*

- *Demonstrate your art in front of them too.*

- *If you are culinary creations, make smells of the food blow into the wind and the crowd.*

- *Create something kids desire and use it to draw the parents in and sell your products.*

These are all examples of creative, proactive selling. Spend some time today before your show, and figure out a plan to make your selling approach *proactive*, and boost your sales. You can easily double your sales with a proactive approach, as opposed to an inactive one.

~ Mistake #4 ~

Too Little, Too Much

As an artist vendor in an arts and crafts show, there is a huge mistake that is a bit of a duality. It is having too little at your booth, and the reverse, too much. Let's examine these two extremes of this particular type of mistake independently:

TOO LITTLE

When a person walking by your booth can see *all* of your products or goods in a single glance, you are most likely looking at a situation where you have too few items to sell. Although they may be great items, you are

choking your sales by too simple an inventory of things to see. Too few items on display will cause a large percentage of the people passing your booth to make a visual scan assessment of your products, determine interest from a distance, and move on if nothing strikes them in that cursory glance.

Imagine going to a grocery store one day that has the shelves stocked full, and in every department. Then compare it to walking into another one where there is one single can of soup on a big wide empty shelf. *What is wrong with this picture?* you might ask when you walk into this store. The scarcity of products therefore becomes a negative, and the store looks poor, or at least it does in the soup department.

Further, if you have a product line that is not diverse enough to create interest, you are losing some customers as well. Let's take an example of a clothing booth. Imagine all you were selling was summer dresses. They are beautiful and appealing, and you are indeed

making sales. However, what about all those sales you are missing on summer dresses simply because there were no other items of interest when a customer walked by? There are still the people who pass through a festival that make a cursory scan of booths and displays, and decide their interest without even approaching your booth. If you do not have enough variety, you are missing this customer, of which there can be many.

Let us say that you realize this and then you added some scarves, and hand bags to your displays in addition to the summer dresses. Then you might see that not only are you tapping into a market of sales with scarves and bags, and drawing a new group of people over to the booth who are then interested in those items, but you may also be able to use these to interest them in the dresses as well.

The basic philosophy on this is that some buyers will have interest in a particular item or product you are selling, and that is what draws them to the booth. They may not see the other items you have on display. It may be out of their field of vision, because they were looking for the hand bags or scarves. It does not mean they will not buy your other products, it simply means they *cannot see* them, even if they are in plain sight. They

have a mental filter in place that narrows their search to a particular group of items, and they will only consider other items if your booth has some of the things they are looking for. If you have only one category of your item, you are missing the chance to sell to this person.

People at an arts and crafts show sometimes are looking for a specific item, or narrow list of items. If you can broaden your product line, but keeping them in the same general category, you might be able to draw those additional people to your booth and make additional sales.

Understand that there will always be people that are not interested in your product at all, and that is okay. However, by breaking out of the 'too little' inventory on display of a particular category approach, and perhaps adding some additional items to tap into a new audience, you are being wise in your business approach as a vendor artist.

Not only should you have more items than just the one type, one should also spread out their displays to break free of *one line of sight*. This too is a way to break the 'booth scanner' out of just walking by, and make them pause. If all of your items are on a single table in front of you, you are operating with a 'too little'

mentality. Try hanging items over your head, over the table and behind you. Place items on the ground, and hang items from the front of the table. Display items in the center, and the right and left side of your booth to spread out the line of vision when someone walks by. So one should display one's products *high and low, right and left* and in *front and behind.*

TOO MUCH

Some artist vendors go to the extreme opposite of the 'too little' approach, and overcrowd their booth with *too much* product. How can this be a problem you might ask? Some products sell better when they are not crowded side by side with other products of the same kind. Let's take an example of birdhouses.

Assume you are a vendor artist who makes birdhouses, and you are overcrowding your booth with the birdhouses you have made. Out of enthusiasm you have them side by side on a table in and in front of your booth as tight as you can put them on the

table. You have them hung side by side above your head, and you have them everywhere on the ground in front of your booth, and in your booth. You are well stocked, and you have squeezed every inch of space to have you products there with the idea that you have a lot to show your customers.

I once saw a vendor who displayed his product this way, and sold very few items throughout the course of the day. When I approached him and suggested he take a few and set them by themselves away from the others, so that people could see just those items he magically started selling. What happened? He had overcrowded his booth to the point that there was no room for imagination for the customer! A customer looking at the product sometimes needs to see it by itself sometimes so they can envision it in their house, or hanging from their porch, etc. As soon as this birdhouse artist did this, he started selling birdhouses. So he quickly spaced out his display a little more, and removed several duplicate items, and stored them in the back of his booth for later, and *boom!* He started moving product!

Another thing that he learned from this change was that having duplicate items of the same birdhouse side by side was working against him too. When he took out the doubles, suddenly some of the unique designs

that he has a few copies of became more unique when on display and they started selling. Too many copies of the same item therefore can take the idea from the customer that they are buying an original piece or unique item, and may not make it desirable.

So if you have to thin out our display, remove the duplicate items first. If you are running short of design, and have doubles, mix them up and place them in separate areas of your booth to create the illusion of diversity and not have them side by side looking the same. Customers can find side by side displays at Wal-Mart or some other major store, but when they are shopping at an arts and crafts show they want to see original works, so keep this in mind when setting up your displays too.

I have seen this happen with clothing sellers too, where they overcrowded a clothing rack to the point that a person interested struggled to sort through them. I have seen little knick-knack artists cover every square inch of a table at a show, and sell nothing. These artists simply omitted allowing room for the customer's imagination, and when this happens, it can choke your sales.

So one learns the following key points to

avoid this mistake from reading this chapter:

- *Do not have too few of an item so that a customer can see your entire booth in one glance.*

- *Have some variety of products to that you can draw in more people.*

- *Display your products both high and low, left and right, and back and front.*

- *Do not over crowd your booth so that you allow no room for your customer's imagination.*

- *Do not have too many duplicate items on display, so that they lose their originality.*

- *Separate duplicate items so they are not displayed side by side whenever possible, to create the illusion of diversity.*

~ Mistake #5 ~

Failing to Draw

"FiVE"

The next biggest mistake vendor artists make is the failure to draw people to the booth. If you cannot lure people to walk over and check out your booth, you are missing out big time.

Call it the law of attraction, or the magic of marketing. Whatever the case, you need something unique and interesting to distinguish your booth from those around you.

Realize at an arts and crafts show, especially the large ones with hundreds of vendor booths, people are

going to pass by the ones that have no interest to them. So you better find a way to make your booth uniquely interesting.

BIG, WEIRD, CRAZY & FREAKY!

One trick is to come up with something weird, big, crazy or downright freaky to capture people's attention. If you are a sculpture artist; how about a real big statue in front of the booth? If you are a wood carver; why not a big wood carving or totem pole? How about a fountain? Or if you have a clothing booth; why not some large flags of the clothing items flying in the breeze above your booth? If you are selling stuffed animals; try making a huge one to place on display!

ATTRACTING FROM A DISTANCE

People walking through arts and crafts fairs will see these things from far away, and be drawn to them. Sometimes even a booth mascot works great, with someone dressed in a costume. Giving out balloon is also an easy gimmick, and works great with kids. Setting up silver Mylar balloons on top of poles, easels and other signage also works great to draw some attention.

WAVING THINGS, FLAGS, BANNERS AND SIGNS

Another great way to draw people it to have eye-catching brightly colored flags, banners, signs or things that move around in the breeze. The object is to have something that no one else has that is bright, attractive and unique. Hoist a big inflatable bear for example with helium and let it fly above your booth, or have a big green stuffed dragon hanging from a tall pole over your entrance as an example.

FREE FOOD

I once saw a wood worker set up a small BBQ grill and gave away free hotdogs, and let people sit on the benches he had at the show. Later in the afternoon, he gave away lemonade, and ice water.

All of these things were an effort to get people to come in his booth and see and test out his wood products. (I would caution you on this approach, as some show coordinators frown on non-food vendors giving out food, so if you are going to try this, you may be required to pay an extra fee to do so depending on the show.)

If you are not attracting people to your booth, then you are ordinary. Try making a change. Smaller things you can do are to add some brighter colors to your signs, banners and flags.

FREE COFFEE, DRINKS & ICE CREAM

Having an espresso machine or coffee maker at your booth can also be a great way to lure people to your booth. This works great especially in the early morning hours. Another great giveaway drink is orange juice or some kind of unique fruit drink. Avoid common things like soda, so as not to appear to compete with food vendors. Soft serve ice cream can be another good gimmick, and also having a freezer on hand with popsicles or ice cream bars can also work great.

Make sure you have a sign on the booth that can be seen from far away, and try to tie in the giveaway drinks to your products. This kind of items work great with T-shirt designer booths, ones that sell pottery and coffee mugs, and also hand sewn items for the kitchen, or kitchen products, etc. Use your imagination!

COSTUMED PEOPLE

Another great gimmick to attract attention is to have everyone in the booth wearing some kind of unique, eye-catching or bright clothing. Go rent one of those full length neon yellow body suits, or wear a big funny hat.

The people in the booth can be the ones that stand out too. Have you ever been to a renaissance festival? The basic condition of working at such a festival is that you dress the part. Why not do so in a festival that is not expecting it?

PLAY MUSIC

Sound can also be a great big attraction. Playing live music is an even bigger one. Have someone sitting there playing a guitar, or singing as a possible way to attract people and get them to pause and go through your booth. This works great for any booth selling music related items, but could work for just about anyone. If you are selling CD's, try playing some of them in your booth for people to hear.

STORY TELLING

I once was at a festival where I booth selling western wear and iron work had a sign up that story telling would happen every hour, and they handed out flyers all over the festival. Every hour, a story teller would sit down in the booth and tell stories and these stories of course included his products he was selling. Kids came, and they lured their parents, and if became a 'cool thing' to take part in during the entire festival. The vendor of course made a killing selling his hand made products too.

GET OUT OF YOUR CHAIR AND GREET!

The wrong thing to do is to just sit in a chair in the back of your booth and watch people wander by. At the very least, you should step out in front of your booth once in awhile and invite people to see your things, or just say 'hello' to get a conversation started. Reach out to people and start up a conversation.

Be friendly, and this alone can be a great form of drawing people to your booth. Try waving at them in the distance or motion for them to come over to your booth. Have fun with the people in the crowd passing by. If you act alive, live people will come your way. If you act lifeless, nothing happens.

WRONG VS RIGHT PRODUCTS

Having the wrong product for a show can also make your show experience difficult. I once spoke with a vendor artist that was doing wooden personalized signs for people at a show. He thought this was going to be a big draw, so they stocked a lot of items in advance for the show.

Then, as an afterthought he created a few items of the kids with some scraps of wood he had laying around. He made some wooden popguns and put them in with his supply of stock to take to the show. The end result was he spent $500 on materials for the wooden signs, and not factoring in his time to prepare which was somewhere around 80 hours of work and he only sold a total of $1200 of his products. Subtract the money he spent on show fees as well, and he barely broke even.

However, he sold completely out of the child's pop guns within matter of hours. Guess what product he brought to and prepared in higher volume for the next show? Right, the popguns! They also were about 50% cheaper and a lot less time consuming to make and he completely shifted his business around and began producing kids' toys with his workshop.

I also knew a friend that had produced this

fantastic line of wooden chairs and took a booth at an arts and crafts show I attended and made few sales despite all his efforts. A month later he did an indoor trade show, and had greater success. So there is a lot to be said about having the right product at the right show, and this also needs to be factored in for vendors.

This is a key point in attracting people to your booth. So rather than invest all of your energy into a single idea that has never been sold in volume before, try spreading out that energy into 5 or 6 products and promote those items combined. You might find surprising results, and the items you think will sell may be slow movers, and the items you never thought would sell will be the first ones to go.

It is a fact that one can have the wrong product at the right show, and the right product at the wrong show. So keep that in mind as well.

The lessons we learned from this chapter are:

- *Do something interesting with your booth to attract attention and draw people.*

- *Original ideas and gimmicks will separate you from other vendors.*

- *Big, weird, crazy & freaky can be good!*

- *Make sure you have the right product for the right show, rather than the wrong product at the right show, or the right product at the wrong show!*

- *Practice and improve upon methods to lure people to your booth and have fun doing it!*

~ Mistake #6 ~

Business Killing Practices

At an Arts and Crafts show that has a lot of people attending, it is hard to kill business to a booth. One really has to work at it. However, some artist vendors take actions that kill their business, and do not realize it. It is not proactive selling that drives people away, as so often is the misconception.

It is the *overwhelming the customer* or a *'not letting them breath'* style of selling that does it, and this is what kills business to the booth. There are also some

things that one can end up doing with set up of the booth itself that drives customers away too. So let's examine the four most common ways that an artist vendor can practice business killing behavior, and drive off customers.

Smothering ~ This is probably the most annoying for a customer, and will make them stay away like the plague. It is when an art vendor hovers over them the entire time they are in the booth and constantly shadows them, sometimes to the point of extreme annoyance. It comes one could suppose either from an *over-zealous nature* or perhaps it is driven by a '*fear that people are all thieves*' mentality, and so one feels the need to smother them in their every move in and around the booth.

Also, some artists are just insecure and nervous at early shows, and therefore feel the need to smother their customers out of desperation or be close at hand to address any negative response they might have to the work.

Whatever the reason or cause, this kind of approach will drive people away, and they will not buy.

Hovering like a shadow near people throughout their visit to your booth will not only make them nervous, and not buy; they will not come back or bring friends back to your booth. If you want to go broke, smother people.

Trapping ~ This is a kind of approach where you invite them in the booth, and then create a barrier with your body preventing them from leaving or freely moving around. They become distracted that you're trapping them in there, and their attention draws off the product and onto *escaping*, which is the wrong thing you ever want your customer thinking about.

This can also be brought about from a poor booth layout, which we discussed earlier, and the trapping can also occur with too many other customers entering the booth and the natural flow of traffic traps people and makes others not want to enter.

Cutting off any means of escape in your booth, whether intentional, unintentional or just bad booth design is a practice that will make people uneasy and become a distraction from their buying. Some of the

booth designs in chapter 2 could be trapping designs with some displays, so you might want to choose another design that is more open.

Never make your booth a claustrophobic atmosphere. On way to create a more open feel when they are in the booth is to not close of all the sides, but leave one of the other side's open or partially open. If one feels they needs to have a booth where people come inside, and there is a lot of product to show them in there, consider getting a double booth side by side at the show and create a more open feel to your layout. Double booths of course cost more, but they can also allow you to show more products, and remove the 'trapping' atmosphere that a small booth can create. It can also boost your sales.

Blocking ~ This is the foolish behavior of placing your body between you and your product. It is setting up your booth so that people have to approach you and ask you to reach behind you and bring out a product so they can look at it.

It usually comes about from having all of your products in the booth, and a table barring the way between

the customer and the products. This is a great way to kill sales. It creates too many barriers from allowing people to touch your product, and make a decision on the purchase. They cannot touch the product without asking you to *pass it to them*, and then they feel even more of a nuisance when they have to ask to see another one, etc.

Some vendors just block entrance to their booth by placing their body or part of it in front of the entrance making it difficult to enter, and thus they decide not to disturb you, and go onto the next booth, and so on. The practice of having all your goods behind you and you having to bring it to them upon request belongs in a carnival environment, and not an arts and crafts show. If you add steps that a customer needs to do to see your product, you are making it too difficult to buy. Change your booth layout, and make your products more accessible.

Repelling - This is any action you take as a vendor that says 'stay away' to a prospective customer. It can be in how you dress, such as personally being sloppy, dirty, or wearing clothing articles with something written or printed on it that others may consider offensive. It can be having strange smells in the booth, or annoying sounds. It can be setting up your displays so they look

cheap, unprofessional or sloppy. Misspelling words in signage or inconsistent numbers in pricing can also repel people.

The attitude or the attitude of someone in the booth can repel people. It can be brought about by engaging in unflattering, obnoxious or rude behavior. No one wants to approach an unfriendly looking person, much less talk to them.

Sitting on your butt in the back of the booth can also repel people, as they feel they are *inconveniencing you* by making you stand up, so they dare not enter. Additionally, having signs that read *"Do not touch"* repels people. It is understood that some items are fragile. Try displaying the items up higher out of reach of children. On can also try using a sign that reads *"Look with your eyes, not with your fingers"*, which tends to be friendlier and encourages looking, but does not repel.

There can be many ways to repel people. If you have a question about what this could be, go walk around a mall or festival yourself, and see what kinds of

actions or people make you want to avoid entering a booth or store, and you will have an idea. It can also be brought about by having a dark and dreary looking booth, with little or no light.

If you are at an arts and crafts show and you notice a lot of people passing your booth but not stopping or approaching it, go out of your booth and stand back and look at it yourself. Walk how people respond when they walk by, and observe their reactions. See if you can find out what is repelling people and change it.

The lessons learned from this chapter:

- *Do not smother people.*

- *Do not trap people or create a booth that does this.*

- *Do not block people or create a booth that does this.*

- *Remove, change or stop anything that is repelling people from your booth.*

90 ~ Arts & Crafts Shows

～ Mistake #7 ～

Choosing The Wrong Show

(SEVEN) One of the most costly and time wasting mistakes an artist vendor can make is to choose the wrong arts and crafts fair, festival or show. One can easily say that if you spend all weekend at an arts and crafts show and made no more money than if you had stayed at home, then you went to a very bad show.

Attending an arts and crafts show as a vendor costs you booth fees, time and any additional expenses you incurred in order to get there. Then, if you are at an overnight show, you will likely incur costs on lodging

and eating out. To make this all worth the money and effort, a show needs to be well attended so that you can sell your products and services.

JURIED SHOWS

So if one is just starting out as an artist vendor, how do you find the right shows to take part in? To start, the best suggestion is to begin with juried shows. Juried shows are ones where the promoter asks for a detailed application on your products, and usually requires you submit samples of your work. They will provide you with guidelines for their show, and it is best to try to submit your application conforming to their guidelines.

Just because a show is juried, it does not mean it is a great show, it just means that they are going to have guidelines for the artists who exhibit which improves the quality of the show overall. For this reason, a juried show is usually one of the better ones to start with.

ESTABLISHED SHOWS & LOCATION

The next thing to look for is shows that have a long

established tenure. There is a big difference between the *1st Annual* Peach Festival and the *32nd Annual* Cherry Festival for example. The likelihood of the Cherry Festival drawing more traffic in terms of people is a lot higher if it has a longer tenure, as opposed to the example of the Peach festival above.

However, location has a bearing on it as well. Being a long established festival in larger populated area may offer higher traffic, but then again a new festival in a smaller community near a popular tourist destination may also be a huge draw. So in doing your research, look at the longevity of the festival you are considering and also the location.

TALK TO OTHER VENDORS

The third, but perhaps the best way to find good festivals is to go to any local arts and crafts festival in the region, and go talk with the more established vendors. Find the ones that are doing several shows.

Ask them which shows they recommend as ones with good consistent traffic, and ones that they have

done well at. Also talk to artist vendors that have a similar product to your own, and ask them which shows they have done their best at.

RESEARCH ONLINE

Makes note of all the ones they tell you about, and then go to: www.festivalnet.com and see if you can find them. This is a national website where most of the larger festivals advertise annual festivals. There may also be some local state festival websites which you can look for online as well.

TALK TO THE SHOW PROMOTERS

Call up and talk to the show promoters if possible. Find out what their projected attendance is. Ask about how they are advertising the arts and crafts show, and also ask about prior year attendance. See if they can give you some names and numbers of other vendor artists that have attended the show in the past that are returning so that you can speak with them.

Find out as much information as you can about the show, but also listen to the reaction of the promoter. *Are they concerned about the impact of bad weather? Will they lose money if that happens?* Festivals that have no risk to the promoters are also ones that can be neglected

in terms of advertising, promotion and are not concerned with your success as a vendor. Evaluate the facts they give you, and make your decision.

FESTIVALS THAT CHARGE FOR ATTENDANCE

Another important thing to find out about an arts and crafts show is whether the show charges people to attend. Shows that are free and open to the public often have more traffic than ones that charge for entry. If they are charging for entry, find out how much they are charging. Also find out if they are charging for parking or other fees. Often times people who attend a show and have to pay to get in tend to spend less money with vendors because they have a budget on how much they want to spend on the day, and if they have already paid for parking and gate fees, this can reduce this budget they have and thus make selling them items more of a challenge.

KEEP RECORDS

Whenever you attend a show as a vendor, make a note for your own records on how well you did. Write

down a summary of the actions you took at the show, and what it was like as a form of a small diary for you to later reference. Also note the costs you paid, the sales you made, and what your overall profit was on the show. Also note if there were some extenuating circumstances you could not control like 'rain' or 'wind' or 'a cold snap' etc.

Keep all these notes in your file for next year, so that when this festival comes around again you have something to refer to other than your own memory. Written records are essential to keeping organized to return to the better shows again. Also if a show is great, seek out the festival organizers before you leave and reserve your spot for next year if you can. Often juried shows will not require returning vendors to re-submit an application again if they reserve at the last festival and apply with the same products, etc.

FINAL NOTES ON ARTS AND THE CRAFTS SHOW SELECTION PROCESS

Attending arts and crafts shows are a gamble. There is going to be some trial and error. Festivals that are good one year can decay and become awful in later years with changing of organizers and demographic changes in the area it is held. One should not just repeat

at prior successful shows if doing this full time.

Established shows can be juried or non-juried. Just because a show is non-juried does not mean it is bad. On the contrary, some of the best ones I have ever been at were non-juried shows. There are a lot of factors that go into whether a show is a good one or not. Try to consider them all.

One should be willing to take on some new festivals a few times a year as well, especially the ones untried. You quite often will find a fantastic one that you can have an excellent show at. Just because a show is new and never been run does not mean you should avoid it. Interview the promoters, and consider the location and take some chances. It is all part of the business. The above guidelines will help you find more successful ones than non-successful ones if you follow them.

Key points to remember in this chapter:

- *Consider juried and non-juried shows, but*

be sure to factor in tenure and location in making your selection.

- *Talk to the promoters and ask questions.*
- *Ask other professional vendors.*
- *Do research for arts and crafts shows online.*
- *Try to find successful shows and be willing to take some risks on new ones too.*

Mistake #8

Poor or No Customer Service

One of the major mistakes that vendors make is in customer service. This can become the silent killer of your present sales and future sales at a show. In this chapter we are going to look at several areas where customer service mistakes can be made, and how to avoid them.

To begin, let's examine some of the areas of bad customer service:

Not being friendly: Being grumpy with people or expressing unfriendly behavior towards anyone who visits your booth will drive not only that customer away, but others who overhear you. If you cannot have a

friendly attitude when doing an arts and crafts show, then you really should not be there and make plans for someone else to run your booth for you. Nothing turns a buyer off than a nasty, cold or unfriendly vendor. Enough said on that point.

Not reaching out and talking to people: Some people who come to an arts and crafts show expect you to approach them and talk to them. Not doing so can position you also as being unfriendly, or not having good customer service.

Making eye contact when you talk to someone: Look people in the eye, and talk to them. Don't avoid their look. Customers like vendors that look them in the eye, and do not avoid them.

Not answering people's questions: At Arts and Crafts shows, people often ask questions. 'How did you make this?' is generally a friendly inquiry. Not everyone is a spy, and you do not have to give away any trade secrets. Simply answer their questions and be friendly about it. Children especially ask questions, and many adults I have seen at arts and crafts shows ignore kids when they do that. Answer them! Treat children like people, and show some kindness by answering

questions. If you want to kill your chances of a purchase, just ignore people's questions about your product. If they do not get answers, they will invent the answers on their own, and those answers will usually result in them not buying.

Not being interested in people or selling your product: Have you ever attended an arts and crafts show and seen someone sitting in the back of their booth reading a book with no one talking to people that are looking at the products? I have seen many. This is also a way to create disinterest in buying your product. Why? This is simply because you are not interested in your own product enough to try to sell it to them. Be interested in people.

Ignoring people: Do not be so caught in your world as an 'artist' that you feel it necessary to ignore people, simply because to you they do not fit your profile of a 'buyer'. I have seen so many vendor artists ignore people that would have purchased if they had simply been shown some common courtesy. I have learned over the years that one can never judge a book

by its cover, and choosing to ignore someone simply because you do not think they will buy from you is bad business. The best frame of mind to have is that everyone is a potential buyer, even the kids, so treat them all with the same respect. Certainly do not sit in corner of your booth and play on your mobile phone or read a book. People are seldom going to approach you to buy; you must be willing to approach them.

Lack of manners: Manners are a cultural thing sometimes, but they are a good business practice. Use 'Yes, Sir' and 'Yes Ma'am' when talking to people. Say 'please', and 'thank you'. It smooths the way for great relationships, and a blatant lack of manners turns people off.

Being shy: Don't be shy in your interactions with the customer. Talk to people, and say 'hello'. It's okay if you are not used to talking to a lot of people. Just do it anyways. The only way you will develop the ability to be comfortable at it is to take some personal risks and talk to strangers. Most people are very friendly, and a lot are extremely interesting. The best part of doing an arts and crafts show is meeting all the amazing people

over the time you are there. Take advantage of it!

Eating habits: Vendors must eat at shows like anyone else. But if you are alone, try to be discrete about it and don't sit there when the booth is full of people while you slowly munch on a hamburger and have food all over your mouth. The best thing to do is to have two people in a booth, and give each person a chance to step out to have lunch while the other covers the booth.

Not having the correct change: When you are at an arts and crafts show, a major part of customer service is having the correct change for your customer. You not only need to have the correct change, you need to be able to make the correct change without error. A sure fire way to turn off a customer or others within earshot is to not have the change or make an error on a person's change.

Not being able to make change on a large bill: I know this can be a problem at any show, especially when the first sale someone hands you a hundred dollar bill and wipes you out of all your smaller bills at the

start of your morning. This is a result of poor preparation, and part of preparation is having change, no matter if someone hands you a large bill.

Not accepting credit cards: At an arts and crafts show these days, you simply need to have a means of accepting credit cards. There are many services that are available today, and even some that you can do right from your cell phone. At the very least you need to have some paper credit card slips that you can accept, and then run after the show.

Not having prices on your items: This is a major mistake in customer service. Put prices on all of your items, and make it clear and easy to understand. People want to know prices, and so make the information easy for them to find.

Not offering price discounts for multiple or large purchases: This kind of thing can upset professional arts and crafts show attendees. They are used to getting deals, so you better have some. Offer a discount for more than one, and also offer specials of the show, etc.

Not offering some kind of freebie: Some people

really like to get a freebie when they make a purchase. Find a gimmick that you can offer them.

Not having business cards or contact info available: If someone makes a major purchase, they like to get a business card from a vendor at an arts and crafts show. If you do not have one, this can be a point of bad customer service. Always have either a business card available or a flyer with your contact information on it to give them.

Advertising something and then not carrying it in your booth: Some shows solicit photos from vendors to advertise for the show in advance. If you advertise an item or product, you better have that in your booth, or this can become an upset to a customer who comes looking for that item. Always carry in your booth anything you advertised in advance.

The best rule of thumb in customer service is to follow the golden rule, and *treat others as you yourself would like to be treated.* If you can think with this, you

will be successful as an art vendor in terms of customer service.

Let's review the key points from this chapter:

- *Always be friendly, and offer the best possible customer service.*

- *Never ignore people.*

- *Talk to customers, and answer their questions, whether or not you think they will buy.*

- *Be able to make change, give exact change and accept credit cards and all forms of payment with ease.*

- *Provide your contact information in your booth for customers.*

- *Offer show discounts for multiple, or large purchases. Consider offering freebies too.*

- *If you advertise it, make sure it is in your booth!*

Mistake #9

Pricing & Money Errors

The next biggest mistake artist's vendors make has to do with money. There many aspects to this error concerning money, but do not worry, I will cover them all in this chapter as it is perhaps the most important for your being able to continue in the business.

To begin, let's talk about pricing.

PRICING

When one is at an arts and crafts show, small

change in terms of coins is cumbersome. Try to avoid pricing your items so that it requires that you have to give coins as change. If you can price items so that they are entirely purchased with bills, and any change given is bills, this is the ideal.

When one is at show, and your products are selling quickly with a crowd of people in front of you, making small change on every purchase is impractical. Therefore when you price something, price it so that it is an even number such as $5, $10, $20, $25 or $50. Do not have prices that are listed as: $4.95, $3.95 or $49.50. This just makes your day way too complicated when you have to give out change quickly.

At a booth, I always want to be able to stand there, talk to the customer and make the sale then give them the product and their change without having to move from that spot. You do this by having your prices even numbers, and change on your person either in your pocket or in a money belt.

Experienced vendors learn this quickly. Keeping your prices at rounded numbers makes your speed of transactions very quick, and it is possible to make multiple sales within a short time in a crowd without having to run back and make change. It also reduces the

probability of error in making change, as if the item is $15 and the customer hands you a $20 your quickly can hand him or her a $5 bill right back and give them their product. Then you can move onto the next sale.

"*What about State Sales taxes?*" you might ask. We always factor this into our cost, and adjust our sales price point to be a round number anyway. We pay the sales tax out of that $20 we accepted, rather than have it be priced at $19 + tax. If you price your products this way, it is much easier to figure out the sales tax with a calculator per item before you go to the show, and work it into the cost than the try to collect it at the point of sale with the customer there. Also, I have found that if you give loose change, you tend to run out a lot and you lose business by running back and forth to the change box.

The next most important thing about pricing items is to make sure the items are priced within reason for what people will pay. If you have something priced too high, it will not sell or will sell slowly if at all. If you get a reputation of having too high prices, you will have customers tell their friends that come back by and you

will lose business that way. You will also have people walking up to look at your booth, see the price tags, and walk away.

Arts and crafts show prices should be reasonable, but they also do not have to be cheap either. The best way to price your items is to research what other vendors are selling it for if it is a similar item, as a comparison. The other way is to experiment with the price you ideally would like to have, and then lower it or adjust it as needed to improve sales. If you find a particular item is selling really well at a price, leave it and don't change it.

Items can be overpriced, and not sell. Items can also be underpriced and cheapen the customer's perspective of you and your product line. So beware of pricing items too cheaply as well. Low priced items may seem like a good idea, but they can also lower your overall profits and hurt your sales by giving the appearance of being 'cheap'. It is better to offer a higher price, and give a discount for multiple purchases rather than lower your price across the boards.

Another important thing about pricing is to make sure people can see the prices! Put price tags on all items, and make them readable and clear. Post signs

around the larger display items, and even put a few that can be seen and draw people from farther away.

Make sure you are carrying items in various price ranges, from low to high whenever possible. Have some smaller priced items in barrels or boxes that people can rummage through and buy from there as well. These kinds of things keep people interested in staying in your booth, and make larger purchases.

POINT OF PURCHASE

This is by far the most important thing about being a professional arts and crafts show vendor. I have mentioned this a few times in this book so far, and it bears repeating here in this section. You must be able to accept all forms of payment possible.

Forms of payment include, of course cash. You must be able to make change as described above, so you need to plan in advance to bring enough petty cash to cover you for the show. If you do run out, make sure you have a plan to be able to run to a bank or nearby store and get some change when needed.

The next form of payment is the written check. You see fewer of these today than a few decades ago, but some buyers like to purchase with them at shows. In all the years I have participated in arts and crafts shows, I have never been given a bad check. This does not mean it cannot happen, but as long as you use some common sense, you should be okay. Always take down the name and address of a person writing a check, and ask to see their driver's license just like any store would. Write down the driver's license number yourself right off the ID. This gives you something to turn into the police at the very least should someone default on a check with you.

The next most common form of purchase is the credit card. You need to be able to accept these at your booth. There are three basic ways that you can do this. You can set up a remote electronic credit card reader, which runs on electricity and run cards that way. The second way is to use an application on your smart phone, and there are many companies that offer those products now. The third is the old fashioned credit card manual swipe machine that makes a rubbing of the card on a special receipt and you have the person sign it after you hand write in the amount of the sale.

With credit cards there are basically three

common types of service you sign up for. One is for accepting Visa and MasterCard, which are the most common cards. The next is to accept American Express cards, and the final is to except Discover cards. They are the main four cards, and require usually three separate billing arrangements or rates with the credit card servicing company you sign up for.

All of these items require that you contract with a credit card servicing company of some sort, and have a means to use their equipment at either your home office or in the field at the arts and crafts show.

At a well run show, they usually have ATM machines either set up the area where people can use them or have the ones in the downtown area clearly marked with extra signage so that customers can go find them should they need to use a debit card that is not through a Visa or MasterCard.

TAKING CUSTOM ORDERS

If you are an artist vendor, you should make yourself available to take custom orders at an arts and crafts show as well. In certain fields of art, such as painting, wood carving or sculpture, taking custom orders is an important benefit from the show. You need to make it know in your booth through additional

signage that you are willing to take custom orders for commissioned work.

Sometimes you get a customer who likes your work, but wants something special painted or carved or crafted for their unique situation, and they are willing to pay for it. Making yourself available to take these orders is an important aspect to being a successful artist.

The best way to do it is by appointment. Have an appointment book in your booth for just such a request. Write down all the information, and then arrange a meeting for when and where to meet. This gives you time to consider prices, if you do not already negotiate one right there.

I once had a booth at an arts and crafts show down the street from my stained and beveled glass store. I was there not so much to sell my work, but more importantly to show my work to potential customers, as most all my work was custom. So I had photos and photos of my work on display for people to look at. I was at this show for two days, and I booked fourteen appointments, and made a dozen really good sales.

So taking custom orders is sometimes a thing than can get lost when one is trying to sell their goods at a show. However, one often gets paid two or three times for custom work as opposed to what you might have sold a pre-designed item in your booth as a vendor. So if you are willing meet with people one on one, and talk to them about custom work for their home, or place of business, be sure to promote and make it known to visitors in your booth that you are willing to take custom orders.

My sister is an artist vendor who sells custom painted frames and adventure maps of the North Carolina region. I have worked a few shows with her selling her maps. She always takes custom orders as a painter at every show she does, and usually will acquire as many as three or four jobs directly or indirectly from every show she does simply by making it known that she will do this, and is willing to talk to people in her booth during a show.

Part of being successful at taking customer orders at an arts and crafts show is being willing to talk to customers, and find out about what is important to them. Talk to them about your work, and create interest in it with them. It also does not hurt to have some extra

photos on hand showing other work that you may have done that is not in display in your booth as well. These kinds of items on hand can become your tools to making more money at an arts and crafts show, and is an important way to make extra money from one show.

In this chapter we covered the following key points that are most important in the subject of making money as an artist:

- *Price your items with round numbers; to make faster and easier transactions.*

- *Do not over price your work, and do not under price it either.*

- *Make sure you have items in different price ranges from low to high.*

- *Make sure people can see the prices on all items on display!*

- *Be able to accept all forms of payment.*

- *Be willing and able to consign or schedule custom orders at a show, and have the tools on hand to present your work for those customers interested in it. Make this service known with signage in the booth.*

Mistake #10

No Identity Capturing/Follow Up

The tenth biggest mistake any arts and crafts show artist vendor can make is to commit the huge omission by not doing anything about the area of identity capturing.

What is identity capturing? It is the collecting of your customer's names, addresses and phone numbers who buy from you and also in this modern day *their email address!* It also includes capturing the identities of people who visited your booth, and did not buy. What do you know about these people? *They attend arts and crafts shows!*

So many artists at arts and crafts show exist exclusively on point of purchase sales from their booth,

and do not even think to capture names of the people who buy from them. *Why is capturing these names important?* Essentially, this is important because it provides you with a resource to reach out to them again in the future as well as by other means and sell them more products and services. Your best customer and easiest one to sell is the one whom has already made a purchase from you!

So capturing identities enables you to create a system where you can build relationships with former clients, and produce more sales. So therefore, identity capturing requires also the additional step of following up with them for future purchases. So this really becomes a two part process. Capturing the identity and creating a system that enables you to follow up. So let's explore both of these points in detail.

IDENTITY CAPTURING

What are the best ways to capture your buyer's identity? To begin, you have to have a booth that engages in proactive selling as described in earlier chapters. You must be able and willing to talk to people, and engage them in conversation to a greater or lesser degree. Identity capturing is not something that one successfully accomplishes by placing it on

automatic. You have to be willing to talk to people, and encourage them to give you their information.

The first thing you have to ask yourself is: how valuable a list of names would be to you that consisted entirely customers that had made a purchase from you or were familiar with your work? What price would you put on a list of 100, 200 or even 500 names of those types of people? While you are considering the answer to that question, let's examine some methods to capture people's identities at an arts and crafts show.

The fish bowl giveaway

The easiest way to start with identity capturing is to place a bowl on your table that allows people to place their business card or contact information written on a piece of paper into it. The draw for them doing this is usually best done with some sort of giveaway item, usually one of the more desirable items in your booth.

In order for this to work, the giveaway item has to be something people want, so you will want to giveaway an item that is one of your most popular pieces and in high demand. To enter into this contest, inform them

that the winner will be notified through phone or email, so make sure they also include that on their slip of paper.

If you do this throughout the show, you will capture names and identities of a lot of people who are your customers and people who have just seen your booth who become your future prospects. The value of this second group of people is that they attend arts and crafts shows, so they could become a future customer for you at a later show if you stay in touch. One cannot stay in touch if you do not have their contact information to do so, so try a giveaway to capture it!

The sign-up sheet

This can be a simple pad of paper that you keep on the table and ask people who purchased or engaged you in conversation to sign up on. This can even be prospects that did not buy for whatever reason, but you still encourage them to sign up for a giveaway contest you are doing or just to *'sign up for our newsletter to find out about our next shows.'*

This second one of asking them to 'sign up for a newsletter' works for those artists that have such a unique product that they literally have fans who are in

awe of their work, and may buy more again in the future. This second approach to 'sign up for a newsletter' may not work as well for booths built around smaller impulse buy items, so in that case I would recommend doing the giveaway to capture names always.

Note: When you provide any sign-up sheet, always write a fake name in the first line with a name, address, phone number and email address. For some reason, people will commonly avoid being the first to sign such a list, but will willingly sign if others have done so. I suppose it appears safe to do so if others have gone there first.

The guest book

This is similar to the basic sign-up sheet, but a little more of a formal approach. This is where you buy one of those professional guest books used at weddings or other special occasions, and have it sitting on an easel inside your booth or near the entrance where people who visit can sign up their names.

You can tie this in with a giveaway of an item or free service if you wish.

This approach is a classy way of saying 'give me your name and contact info' and works well for the specialty artists who create larger more expensive works.

Note: When you provide any guest book, always write a fake name in the first line with a name, address, phone number and email address. Just like the basic sign-up sheet, people will commonly avoid being the first to sign such a list, but will willingly sign if others have done so before them.

Live Internet sign-up

If you are at a show where you have electric power and can arrange internet access, you can also set up a sign-up form where people can sit down and take a survey or enter a contest by filling out information right in your booth online, and this captures their identity. You do not see this often at outdoor arts and crafts shows, but sometimes at indoor shows this is much easier to do.

It is not a common practice now, but it is a practice done at a lot of professional trade shows and so I thought I would include this here for those artists that are also

computer savvy and interested in trying this approach. It may become a common practice in the future as technology evolves, so it is worth considering and exploring. I will go into more on this further down in this chapter, however, this makes for a paperless lead capturing approach right in your booth and it can save a lot of time.

If you set something like this up, it works best to have multiple computers or another means for paper lead capturing that you are using as well, as people can be slow in entering info on a computer.

The nudge

If you have the luxury of having a few extra volunteers helping you with your booth, it is always a good idea to assign at least one or two of them the task of identity capturing by having them man the station where you have a sign-up form or drawing, and have them nudge people who come to the booth to enter.

I have found that setting up a contest bowl or offering any kind of sign-up sheet does not mean that people will automatically enter their name; in fact most will not do so unless prompted. My best advice is to have someone who is the most dynamic or 'willing to talk to people' personality to be responsible for this job at your

booth.

At professional trade shows, they usually select the prettiest young girl, or handsome young man to perform this role. If you do not have such a person helping you, that is okay. Choose a young child who is cute and willing to talk to people, or anyone who is can be irresistible to people so they will not say no.

Most anyone can become good at this role if one practices. It takes the willingness to charm people, flatter them, tease them or just be overtly friendly to them and repeatedly ask people to sign-up all throughout the show.

Costumed characters

I have seen some arts and crafts show vendors use a costumed character to perform this duty of asking for sign-ups. If it is a full body costumed suit, often the person wearing it does not have to do anything other than gesture to the sign up book, bowl or list and act like a character. You can get away with a lot as a costumed character, and it is a great draw for kids.

People love to have their picture taken with a costumed character.

The person wearing the suit should give out high-fives, hugs and basically be larger than life without getting too caught up in the role to forget the sign-up sheet, book or contest. Doing the costumed character stunt works best on cooler days, and ones that are not likely to get someone caught in the rain.

Doing this on a hot July day at a show can really limit a person's time in a full body costume, as they can get quite warm and it is akin to walking around with a sleeping bag all over your body, even if they are ventilated and have a built-in fan. A better costume for a hot day is to dress like a clown, pirate or some other character that does not require a full body suit.

Creativity is the magic

One can get creative as one would wish with identity capturing, and there certainly can be many ways to do this. What you are trying to obtain is the customer or prospects name, phone number, address and email address. Quite honestly if you can at least get a name and email address, you can turn these lists into a gold mine for future shows and sales for you.

If you find it too complicated or slow to ask for all of their contact info, one should then simply focus on going for just the name and email. With those to basic pieces of information you can do a lot with future promotions.

FOLLOW UP

The value and return from the efforts of identity capturing comes from having a system in place for follow up. There are many ways to do this, and any artist should have at least some system in place for contacting people again.

Now let's examine some of the various ways to do this from the very simple, to the more automated and sophisticated. All are easy to do, if you are willing to take the time to stay organized with it. It is well worth the advantage it can give you in future sales.

The very simple, non-computer method

Some vendor artists are not computer savvy at all, and need a basic system to be able to contact their former customers and prospects without using a computer. Today, there are some very simple ways to do this with just keeping paper records.

The easiest and least technically complicated way

Arts & Crafts Shows ~ 127

will require that you at least own or have access to a copy machine, and know how to use one. You can purchase brands of mailing labels (example: Avery labels), and in those boxes of labels there is usually a black and white template of which you can make copies of and use to hand write in or type with a typewriter the names and addresses of the identities you have captured.

From this you can build a master list, and one that you can make copies of using the mailing labels and have a means to mail these people information about your business. Keep hand writing or typing onto your list and expand your files on each and every show, and keep these as your master list. Whenever you want to send out a mailing, you can simply use a copy machine and copy these names onto labels and peel off and attach these printed labels to your mailing.

If you want to send out a newsletter or postcard to let people know about your next show, you can coordinate with a local printing company to make these

items for you or hand draw them out yourself and use your copy machine to print them onto postcard stock paper. Then cut them into postcards or fold them into newsletter and mail them with postage attached.

This is perhaps the most basic approach for those who are not familiar with computers, but certainly not the most cost effective one. Paper, printing and postage mailing can be more expensive over time to use for this style of marketing, and due to cost can mean that you cannot afford to do this frequently. However, it is it a very non-technical way to go about it, and is better than having no system in place.

Computer lead capturing methods

If you have some basic working knowledge of how to use a home computer or the internet, there are a lot of ways to manage your lists and make contacting your people very easy.

The first would be to get a copy of the program Excel from Microsoft, and learn to use it. You can set up a template and manually enter names into a master list and use this

list to export them to a mailing label format and print mailers as needed. There are also several other lead management software services you can sign up for online that will enable you to do this as well, and here are a few website that you can explore:

<p align="center">www.ConstantContact.com

www.PrintManager.com

www.FreeLanceTech.com</p>

The next and perhaps the most low cost and easiest way to manage leads and stay in contact is to exclusively focus on names and email addresses, and send out email newsletters and reminders of upcoming shows.

This is best done in coordination with having your own website too, that way you can put your website on all of your contact information and people who you miss capturing as an identity can perhaps visit your website later on in the privacy of their own home, and sign up for your newsletter if they wish.

Setting up a website does not have to be an expensive proposition these days. There are many ways to do this on your own, depending on your level of skill, at minimal cost or for free.

Here are a few sites I suggest you start with to find out how to set this up:

<p align="center">www.hostgator.com

www.webstarts.com

www.webs.com</p>

You can also go to YouTube and search for *how do I create a website* and watch several videos with patient instructors taking you step-by-step through the process on how to do this. They make it a very easy process; give you insight to what works best and make it simple. It certainly is something even someone with basic internet and computer skills can master these days.

Websites can be set up to offer point or purchase sales directly on your website as well, so this is another great way to build online sales for your products and make additional money from existing customers.

To find out how to do this, search '*setting up an e-commerce website*' on YouTube and you will find several useful videos that teach you how to do this. Today it is possible to set up an entire website on your own for less than a few hundred dollars, and maintain it for a cost of less than $20 a month if you do your research. These kinds of websites can make a lot of unexpected sales for your, so they are well worth it if you

intend to build an established business and have it for several years.

Once you have a website set up, you will want to sign up or a separate service that allows you to manage email list and create your own newsletters. If you search on the internet, you can find several companies that provide you with this service. They provide you with a link or 'widget' once you set up your account with them that you can add to your website and capture leads and identities from there, but also enable you to enter names onto your list that you captured from your shows and manage your lists.

The email management service I recommend because it is user friendly is: *MailChimp.com*, because they enable you to tag your lists into groups, which can work great for you to email former customers if you group them into shows you attended. When you return to that show, you can send out an advanced

email and remind them to come see you again.

MailChimp.com is entirely free up to lists of 2000 and then they begin to charge you a low monthly rate for the service. A mailing list of 2000 would be quite an achievement for an arts and crafts show vendor artist, and it one is using a list that large, certainly one is making money with it and can afford the additional fees. Until you reach that size, it is an awesome way to stay organized for free.

Using your identities captured with awesome follow up tricks

Newsletters: Services like mailchimp.com have platforms where one can create a newsletter, and custom sign up forms that you can add to your website. A newsletter can be created months ahead of time, and set up to automatically be sent to your list on specified dates, even if you are on the road all summer. That way your mailing list is working for you by means of pre-set automated advanced emails while you are on the road.

Additionally, as mentioned earlier, if you want to set up a computer at a show and have people sign up right there, you can just open up the form on your website and have them enter their info right at your booth. This is if you want to really get sophisticated with

it and have a paperless lead capturing system right in your booth.

While at the show: Once you have names from a show, you may want to enter them into your mailing database after each show. This way you can constantly build upon a master and even sub-lists and stay organized with it. With online access, you can even go back to your hotel room the evenings you are at an overnight show and enter the identities you collected that day. Send all of your daily visitors an exclusive coupon for the next day, and see if you can get them back for additional purchases.

Coupons: With any identity collection and follow up program, always think with rewarding everyone who signs up. Make them all winners by giving them a coupon to use for a discount on your website, or at your next show. Invite them to give this coupon to their friends, and email it to them.

Advanced reminders: Once you have collected names, you can email people in advance letting them know the next arts and crafts show you are going to be at. At first you can email your entire list, and keep them all notified. If you are traveling around and doing several shows, you might want to sort out the names by

the show, region or State you captured it in and send out advanced emails to your 'Georgia' or 'Florida' customers for example.

Once a list grows, you can selectively mail reminders to groups by staying organized with mailing list management software.

SUMMARY

When one is looking at the subject of identity capturing and follow up, there are systems for every artist depending on what they are willing to do. The most important thing to remember is that identity capturing is important, and even if you do not have a computer, or the time to learn. Then all identities should have a system in place to follow up.

One should have at least a basic system working that you expand on later or hire someone to manage for you. The best system to have is one that works for you. Any system is better than no system.

So how much is a

list of customer names and prospects that have seen your product to you? If you read this chapter, you are probably realizing the income potential from such a list. What has been presented here is a low cost way for you to obtain the information.

Certainly one has the expense of the item one is giving away, and the costs involved in setting up follow up systems, but the return on this investment into the future can be huge. Having a point of purchase system online that is connected to your arts and crafts show booth activities can help you make sales 24 hours a day, 7 days a week and your shows can become merely the launch pad to an even bigger business as a professional arts and crafts show vendor.

So in this chapter we have learned the important key points:

- *Capture identities at every show.*

- *Create a website to capture identities as well as make future sales.*

- *Use these identities to follow up, stay in contact and expand your business.*

Summary of ~Key Points~

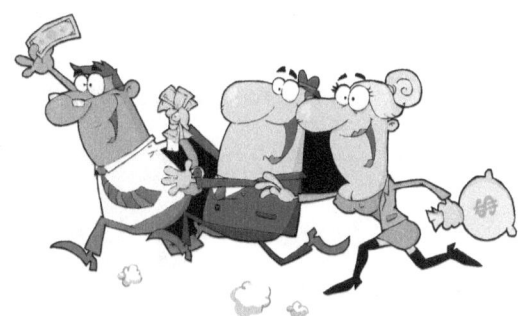

Throughout this book, key reminder points have been placed at the bottom of each chapter. Here is a complete list for your easy reference to summarize this book, and refer to from time to time in the future.

This can be used as a basic check list as well to help build your arts and crafts show vendor business:

Chapter One: Preparation & Organization

- *Be prepared.*

- *Organize with lists.*
- *Prepare for Mother Nature.*
- *Bring your festival paperwork.*

Chapter Two: Booth Basics

- *Invest in a tent or awning.*
- *Be conscious of your booth set up, and managing the flow of traffic.*
- *Remember to have good signage and displays.*
- *Do not forget the back or sides of your booth.*
- *Offer discounts or show specials.*
- *Give out your contact information with every purchase minimum.*
- *Man your booth!*
- *Have a plan to help customers with larger items.*
- *Make your items portable or have a system*

where they can buy and come back for it later.

- *Bags are good!*

Chapter Three: Inactive Vs Proactive Selling

- *Talk to people.*
- *Create things for people to touch and feel.*
- *Ask people to try the product on for size.*
- *Show the people how it looks in their hands, on their person, etc.*
- *Explain the product to them, and invite them to come closer to see it.*
- *Create the product in front of their eyes, and dazzle them into buying.*
- *Demonstrate your art in front of them too.*
- *If you are culinary creations, make smells of the food blow into the wind and the crowd.*
- *Create something kids desire and use it to*

draw the parents in and sell your products.

Chapter Four: Too Little, Too Much

- Do not have too few of an item so that a customer can see your entire booth in one glance.

- Have some variety of products to that you can draw in more people.

- Display your products both high and low, left and right, and back and front.

- Do not over crowd your booth so that you allow no room for your customer's imagination.

- Do not have too many duplicate items on display, so that they lose their originality.

- Separate duplicate items so they are not displayed side by side whenever possible, to create the illusion of diversity.

Chapter Five: Failing to Draw

- Do something interesting with your booth to

attract attention and draw people.

- *Original ideas and gimmicks will separate you from other vendors.*
- *Big, weird, crazy & freaky can be good!*
- *Make sure you have the right product for the right show, rather than the wrong product at the right show, or the right product at the wrong show!*
- *Practice and improve upon methods to lure people to your booth and have fun doing it!*

Chapter Six: Business Killing Practices

- *Do not smother people.*
- *Do not trap people or create a booth that does this.*
- *Do not block people or create a booth that does this.*
- *Remove, change or stop anything that is repelling people from your booth.*

Chapter Seven: Choosing The Wrong Show

- Consider juried and non-juried shows, but be sure to factor in tenure and location in making your selection.

- Talk to the promoters and ask questions.

- Ask other professional vendors.

- Do research for arts and crafts shows online.

- Try to find successful shows and be willing to take some risks on new ones too.

Chapter Eight: Customer Service

- Always be friendly, and offer the best possible customer service.

- Never ignore people.

- Talk to customers, and answer their questions, whether or not you think they will buy.

- Be able to make change, give exact change and accept credit cards and all forms of payment with ease.

- Provide your contact information in your

booth for customers.

- *Offer show discounts for multiple, or large purchases. Consider offering freebies too.*

- *If you advertise it, make sure it is in your booth!*

Chapter Nine: Pricing & Money Errors

- *Price your items with round numbers; to make faster and easier transactions.*

- *Do not over price your work, and do not under price it either.*

- *Make sure you have items in different price ranges from low to high.*

- *Make sure people can see the prices on all items on display!*

- *Be able to accept all forms of payment.*

- *Be willing and able to consign or schedule custom orders at a show, and have the tools on hand to present your work for those customers interested in it. Make this service known with signage in the booth.*

Chapter Ten: Identity Capturing & Follow Up

- *Capture identities at every show.*

- *Create a website to capture identities as well as make future sales.*

- *Use these identities to follow up, stay in contact and expand your business.*

Arts & Crafts Show Links

The following are a list of arts and crafts show website links that promote a lot of the festivals, fairs and shows around the U.S. and Canada. There exist many individual websites for States as well, but these are some of the major ones to help you find arts and crafts fairs, festivals and shows in most areas.

www.Festivalnet.com
www.ArtFairCalendar.com
www.SunshineArtist.com
www.CraftLister.com
www.ArtsCraftsShowBusiness.com
www.FairsandFestivals.net
www.SmartFrogs.com

About the Author

Michael Delaware is a Phoenix, Arizona native who now resides in Battle Creek, Michigan with his wife Margarita. He also lived in Georgia for 15 years in the 1980's and 1990's where he owned and operated a stained and beveled glass studio in the Metro-Atlanta area. During those years he was an active volunteer in the community, coordinating annual Arts and Crafts Festivals in the downtown district of Roswell, Georgia. He also participated in Arts & Crafts Shows for over 25 years as a vendor in numerous States. He has been a Michigan resident since 1999.

His other published works include numerous non-

fiction books on real estate, sales management, marketing and other self-help topics. He has also published fiction and non-fiction stories for children

As an illustrator and photographer, he has included his works in his own books and blogs. He enjoys hiking and mountain biking in the great outdoors and taking long walks in the woods with his dog.

Currently he is an active Realtor in Michigan and frequent community volunteer. He is a member of the National Association of Realtors, The Council of Residential Specialists, and the Michigan Association of Realtors. He is also an active member of the Battle Creek Area Association of Realtors where he was awarded 'Realtor of the Year' in 2010, and served as Board President in 2011. He founded his own independent publishing company in 2012.

To follow Michael:

www.MichaelDelaware.com
Facebook.com/MichaelDelawareAuthor
Goodreads.com/MichaelDelaware
Amazon.com/Author/MichaelDelaware
Linkedin.com/in/MichaelDelaware
@MichaelDelaware

Other titles by the author available as eBooks:

The Art of Sales Management: Lessons Learned on the Fly *(also available in print)*

The Art of Sales Management: Revelations of a Goal Maker *(also available in print)*

The Art of Sales Management: 75 Training Drills to Build Confidence, Excellence & Teamwork *(also available in print)*

Small Business Marketing: An Insider's Collection of Secrets

Arts & Craft Shows: 12 Secrets Every Artist Vendor Should Know

Inspiration: The Journey of a Lifetime

For Real Estate:

Understanding Land Contract Homes: In Pursuit of the American Dream

150 ~ Arts & Crafts Shows

Land Contract Homes for Investors

Going Home... Renting to Home Ownership in 10 Easy Steps

In Children's Fiction:

Scary Elephant Meets the Closet Monster

In Children's Non-Fiction:

My Name is Blue: The Story of a Rescue Dog

More titles will be available in print in late 2013 and in 2014. For a current list of available print books visit:

www.ifandorbutpublishing.com

Don't miss this other book by the author:

Find this title and more at:
www.IfAndorButPublishing.com

www.ingramcontent.com/pod-product-compliance
Lightning Source LLC
Chambersburg PA
CBHW030744180526
45163CB00003B/914